せかいをかえたいなら ほんきでふざけろ

JN081129

もりむら やすまさ
Morimura Yasumasa

Want to change the world?
Be seriously unserious

まえがき
Foreword

こんにちは
びじゅつかの
もりむらやすまさです

Hi.
I'm Morimura Yasumasa,
and I'm an artist.

これから　みなさんといっしょに
びじゅつかんを　おとずれて
びじゅつかんしょうを　はじめます

I'm going to be taking you
to an art museum
for a look at some art.

ちょっとかわった　びじゅつのみかた
ハラハラ　ドキドキ
たのしんでくださいね

But it's not just any trip to an art museum.
Get ready, everyone:
It's time to see art from a new perspective.

もくじ
Contents

ほんきであそぶと せかいはかわる

ほんきで　であうと
ほんとうの　ともだちになれる

ほんきで　はなすと
ほんねの　きもちがあらわれる

ほんきで　あそぶと
ほんものの　せかいがみえだす

Want to change the world? Be seriously unserious

Be serious about meeting encountering,
and you'll make real friends.

Be serious about talking,
and you'll speak your real heart.

Be serious about playing,
and you'll see the real world.

ひっくりかえす

さくひんには　おもてとうらがある
だけど　びじゅつかんでは
いつも　おもてしかみえない

ちやほやされるのは　いつも　おもてだけ

Room 1: Paintings

Turn it around

Every piece of art has a front and a back,
but a museum only shows you
the front.

The front side gets all the attention.

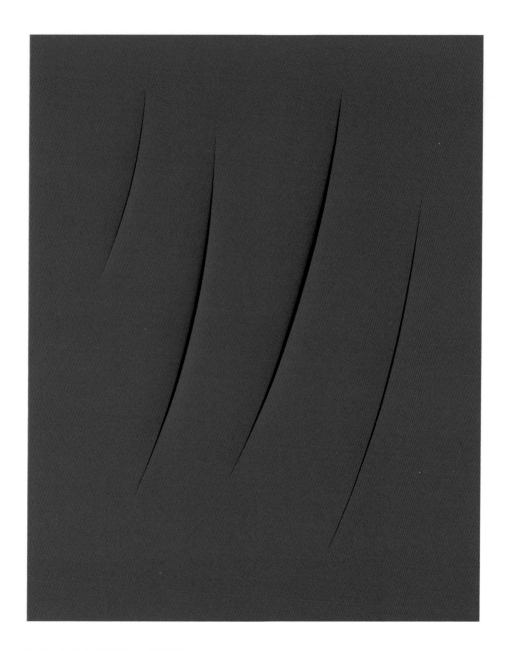

ルーチョ・フォンタナ《空間概念——期待》1962
Lucio Fontana, *Concetto spaziale——Attese*, 1962

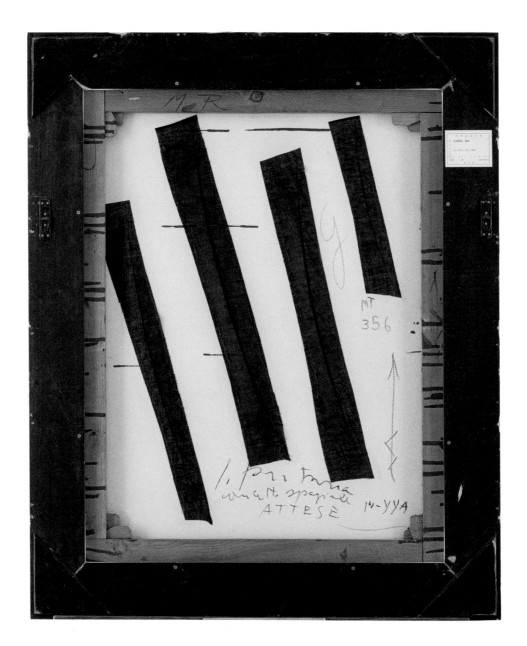

ルーチョ・フォンタナ《空間概念——期待》(裏面)1962
Lucio Fontana, *Concetto spaziale——Attese* (Back), 1962

そこで　わたしは　おもいきって
さくひんを　ひっくりかえし
うらがわと　かたりあってみた

So I decided to turn things around,
literally, and see what the back side
had to say.

かいがのうらがわには　わたしがえがいたのだという
そのひとのあかしが　のこされている

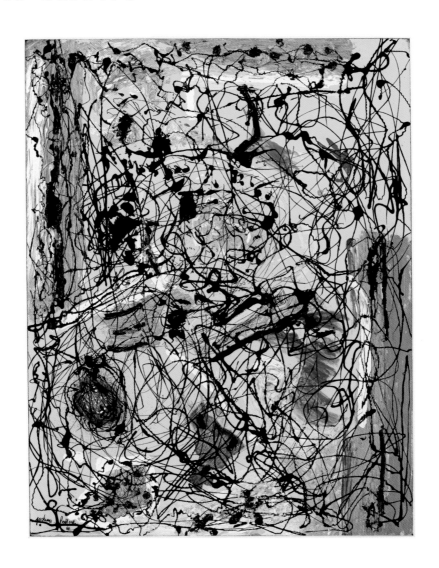

ジャクスン・ポロック《無題》1946
Jackson Pollock, *Untitled*, 1946

On the back side of a painting

is the artist's testimony, proof that "I painted this."

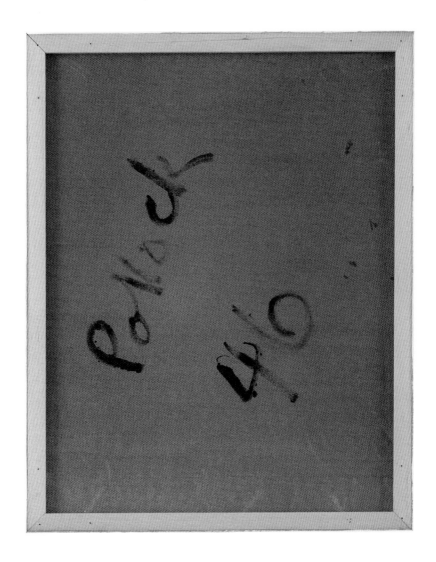

かいがのうらがわには　アトリエで　えのぐまみれになった
おもいでが　かいまみえる

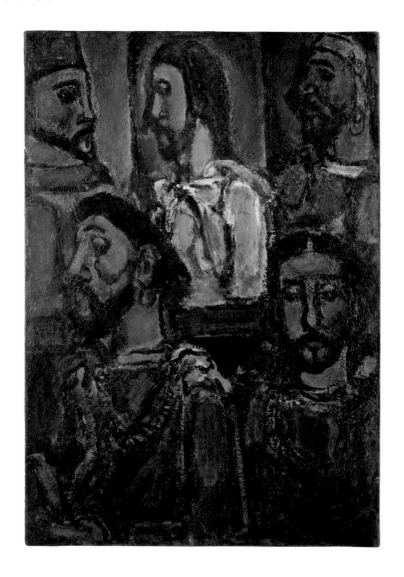

ジョルジュ・ルオー《パシオン》1943
Georges Rouault, *Passion*, 1943

On the back side of a painting is a peek behind the scenes,
a glimpse of the messy, paint-strewn studio where the work came to life.

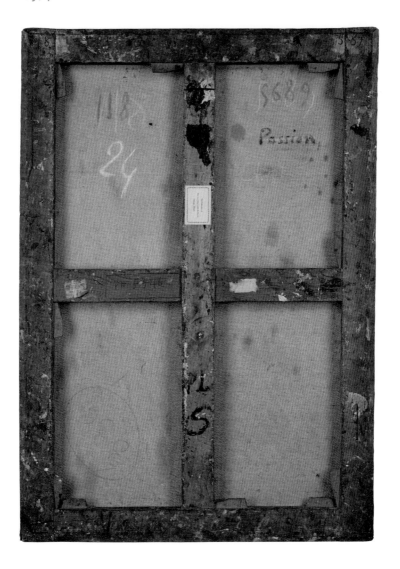

かいがのうらがわには　それをかいたひとの
ひとりごとが　かくされている

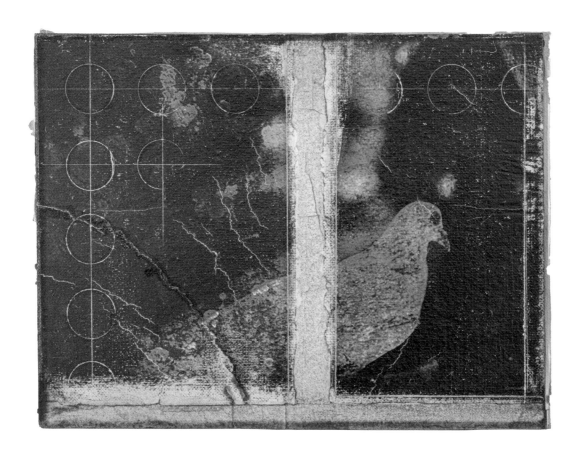

ジョセフ・コーネル《ホテル・フローレンス（ペニー・アーケード・シリーズ）》1960 年代半ば
Joseph Cornell, *Hotel Florence (Penny Arcade Series)*, Mid 1960s

On the back side of a painting
is the artist in monologue, thinking out loud.

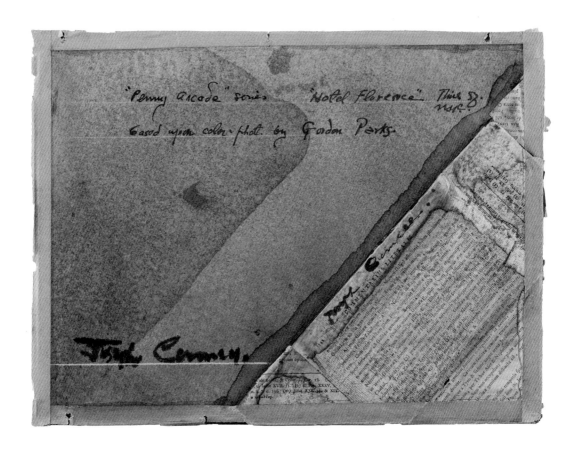

いっしょうけんめい　かいているから
うらがわに　えのぐがにじんでいるね

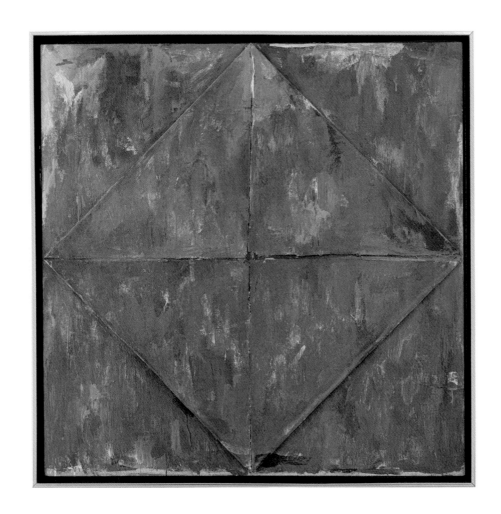

ジャスパー・ジョーンズ《消失II》1961
Jasper Johns, *Disappearance II*, 1961

Sometimes, an artist paints so hard,

so passionately, that the paint bleeds through to the back of the canvas.

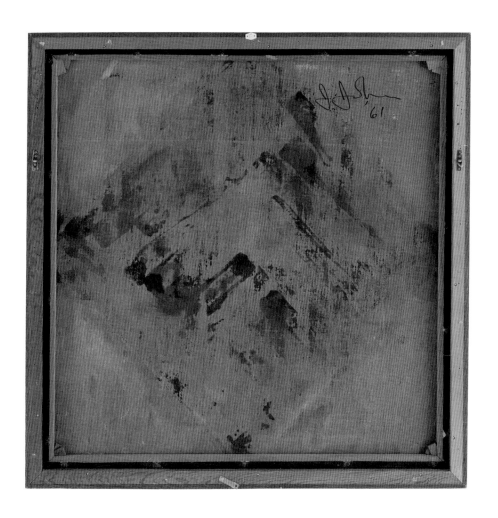

うらがわにも　あかやきいろで
ちいさくなにか　えがいてある
えがいたひとの　くふうが
なぞめくしるしとなって　のこされている

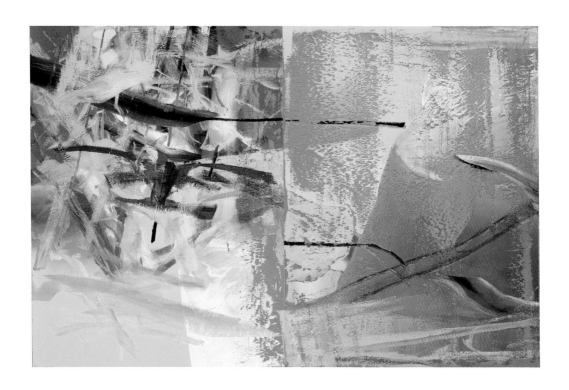

ゲルハルト・リヒター《オランジェリー》1982
Gerhard Richter, *Orangerie*, 1982

Red marks here, a yellow bar there,
coming together like their own work of art,
traces of a creative mind leaving enigmatic signals.

おもても　うらも
どちらも　おもしろいね

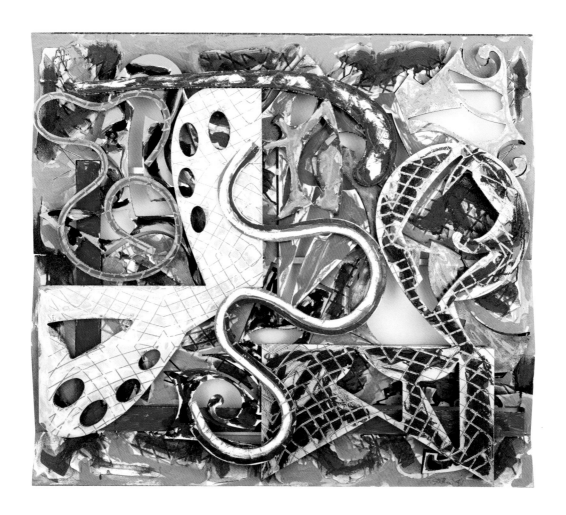

フランク・ステラ《タラデガ》1981
Frank Stella, *Talladega*, 1981

Front and back,
paintings are full of wonder.

かいがだけじゃなく

わたしにだって　あなたにだって

おもてがあって　うらがある

みんなのまえでは　わらってみせても

こころのうらがわでは

かなしかったり　おこっていたり……

Paintings aren't the only things with two sides, though.

You and I and everyone else

have a front and a back, too.

Someone might put on a smiling face,

but there might be a back side to that front:

sadness and anger behind the surface.

こんな　ふしぎなかたちの　さくひんをみたら
そのうらがわが　どんなふうになっているのか
しりたくなって　こないかな

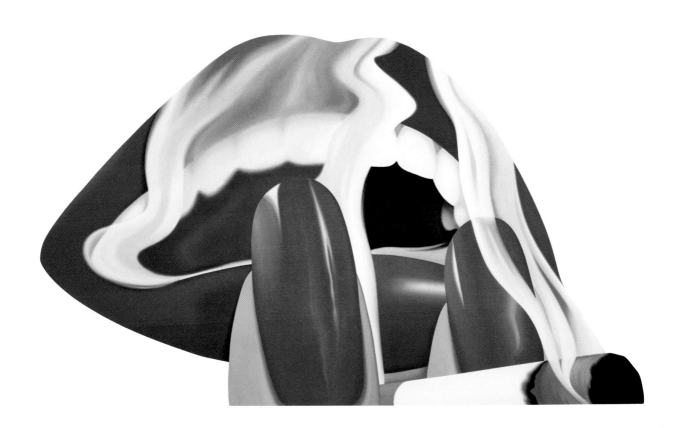

When you see something as curious and compelling as this,
don't you want to know what it looks like
from the back?

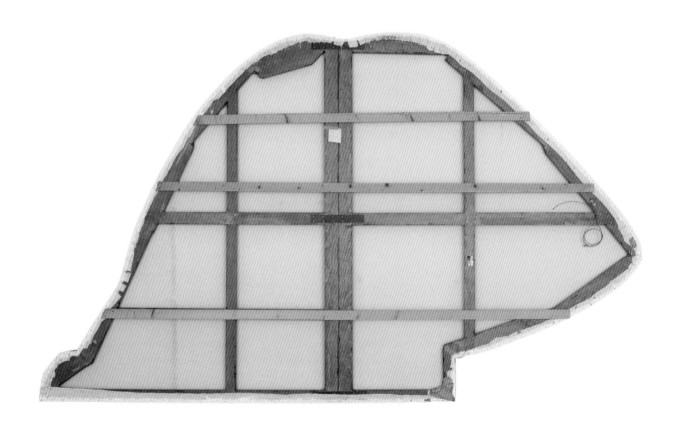

あれ？
このさくひんは　どちらがうらで　どちらがおもて？
うらもおもても　どちらもすごい

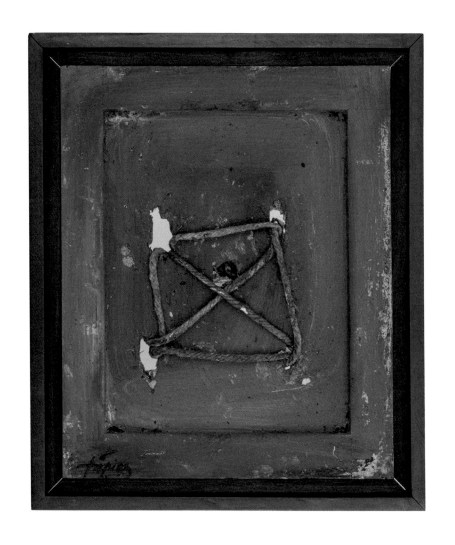

アントニ・タピエス《ちいさな木とひも》1973
Antoni Tàpies, *Petit boi et corde*, 1973

Look at this one.

Which side is the front? Which side is the back?

It could go either way—and either way, it's captivating.

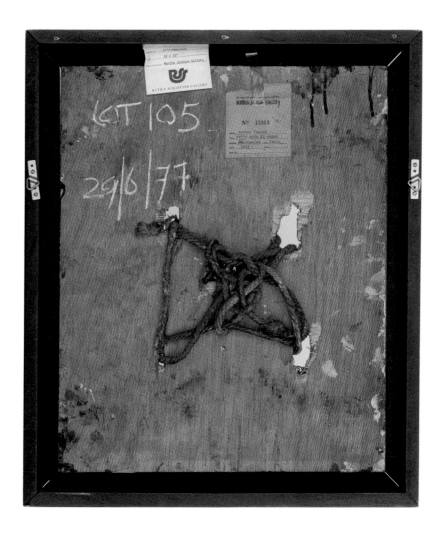

その2　イスの　てんじしつ

いたずらも　たまにはちょっと　やるといい

イスのしごとは
あなたに　すわってもらうことだけど
いつも　おしりのしたじきじゃ　かわいそうだ

だから　いっしょにあそばないかと　さそってみよう

Room 2: Chairs

A little mischief never hurt anyone

A chair's job
is to give you a place to sit,
but who would enjoy getting sat on all the time?

Why not give chairs a chance to have a little more fun?

**イスと　いっしょに
ダンスを　してみたり**

You could dance with a chair.

森村泰昌《イームズチェアがおどるとき》2020
Morimura Yasumasa, *Dancing Eames Chair*, 2020

チャールズ&レイ・イームズ《イームズシェルサイドチェア》デザイン：1950−53
Charles & Ray Eames, *Eames Molded Fiberglass Chair*, d.1950−53

ときには　イスだって
とんでみたいと　おもうかもしれないね

A chair might even want
to take to the sky.
Who knows?

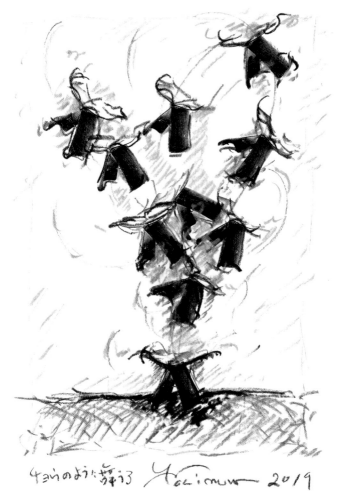

森村泰昌《バタフライ・スツールがとびまわる》2020
Morimura Yasumasa, *Fluttering Butterfly Stools*, 2020

柳宗理《バタフライ・スツール》デザイン：1956
Yanagi Sori, *Butterfly Stool*, d.1956

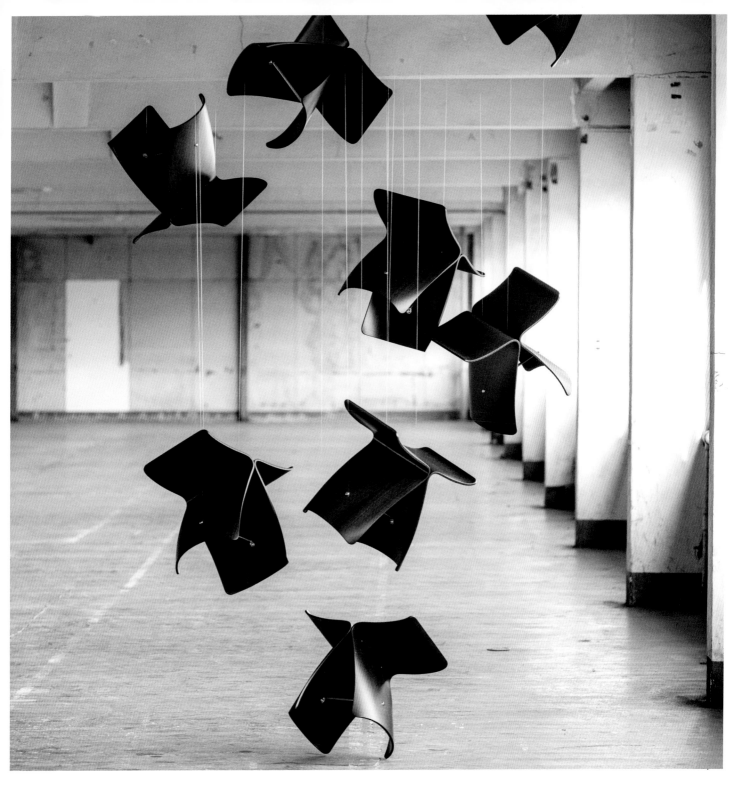

ロボットと　ガッタイさせてみたり

You could pair a chair with a robot, too.

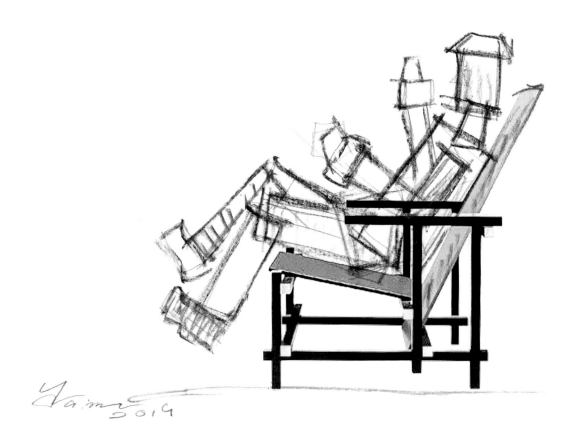

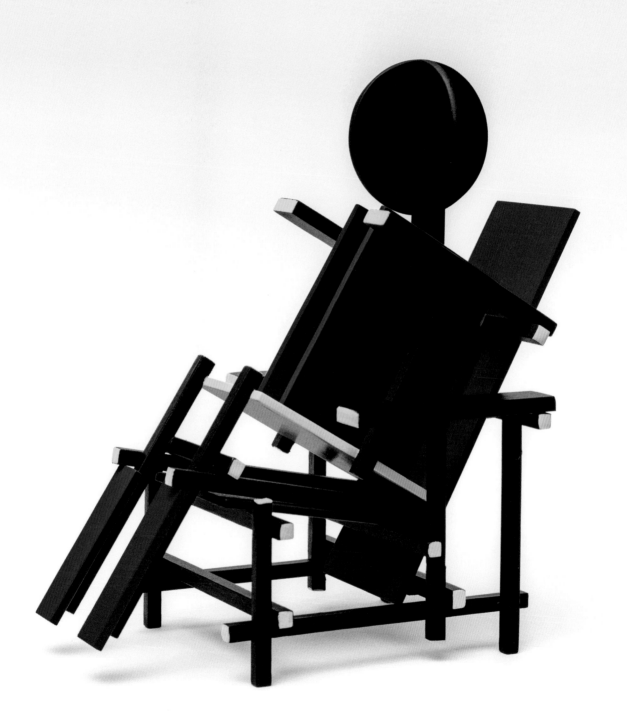

イスと　ロボットと
そしてニンゲンも
ガッタイさせてみよう！

Or create a trio:
a chair, a robot, and a person!

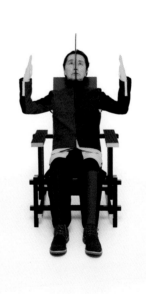

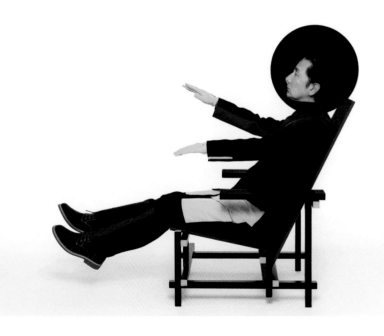

森村泰昌《リートフェルトにすわるにんげんはロボットになる》2020
Morimura Yasumasa, *Rietveld Meets Robot Meets Person*, 2020

ヘリット・トマス・リートフェルト《レッド・アンド・ブルー》デザイン：1918−23（製造：1990年代）
Gerrit Thomas Rietveld, *Red and Blue*, d.1918−23（production：1990s）

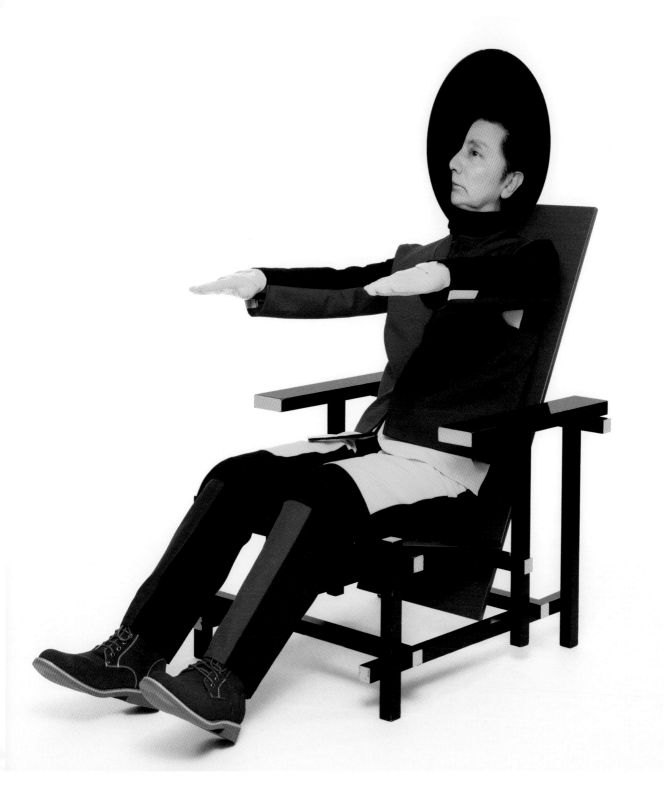

きふじんのような
エレガントなイスには
バラのはなを　ささげよう

Or accentuate a ladylike chair
with some beautiful roses.

森村泰昌《バラいろのじんせい（ミス・ブランチ）》2020
Morimura Yasumasa, *La Vie en Rose* (Miss Blanche), 2020

倉俣史朗《ミス・ブランチ》デザイン：1988（製造：1994頃）
Kuramata Shiro, *Miss Blanche*, d.1988（production：ca.1994）

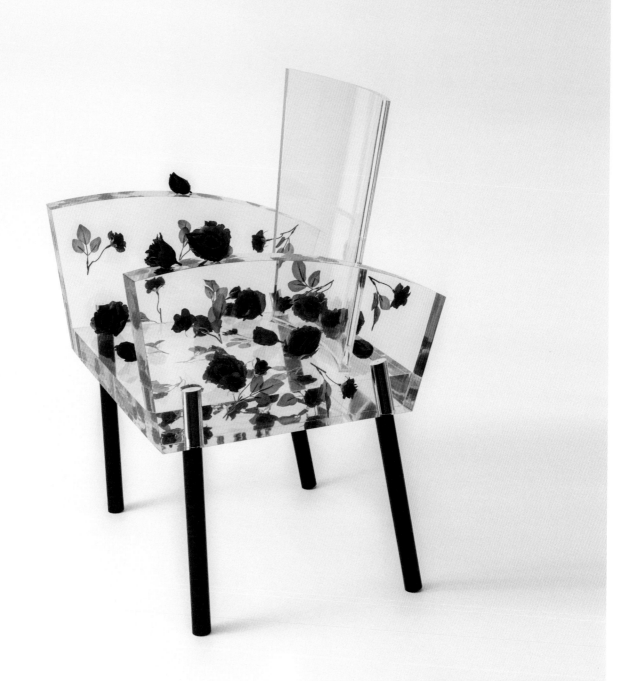

いとしいイスには
バラのはなのドレスを
プレゼントしてみよう

Or show your love for your favorite chair
with the gift of a rose dress.

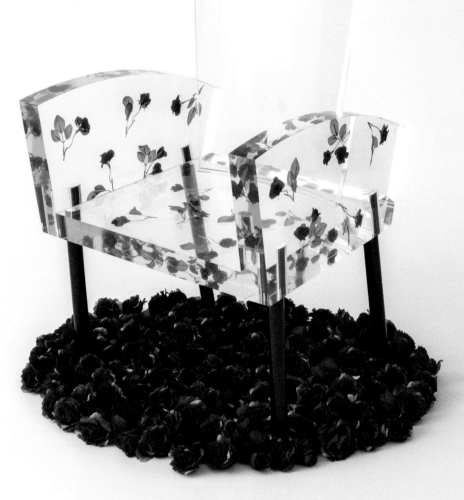

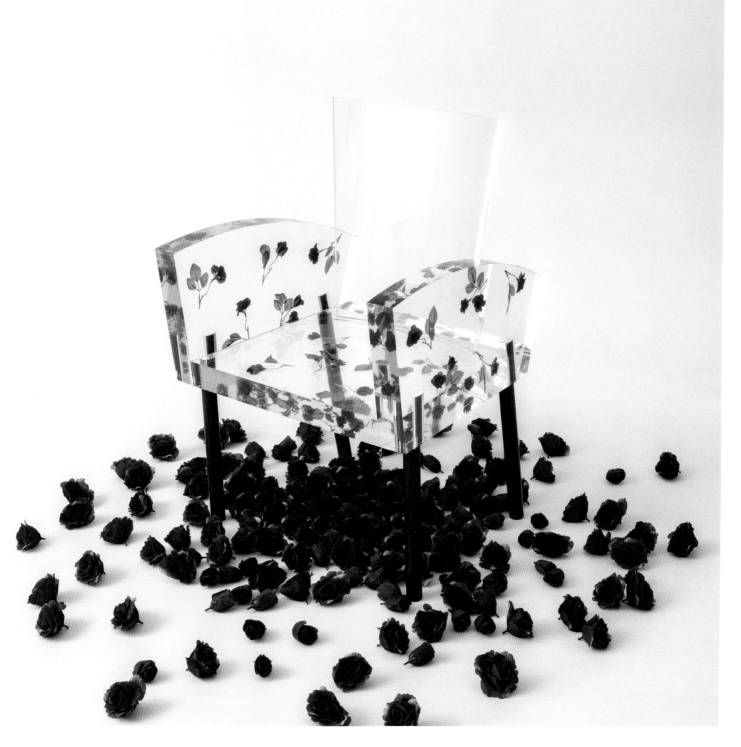

イスたちが　あつまると
サーカスが　はじまるよ

Get a bunch of chairs together
for a circus act to remember.

森村泰昌《イスのサーカス》2020
Morimura Yasumasa, *Chair Circus*, 2020

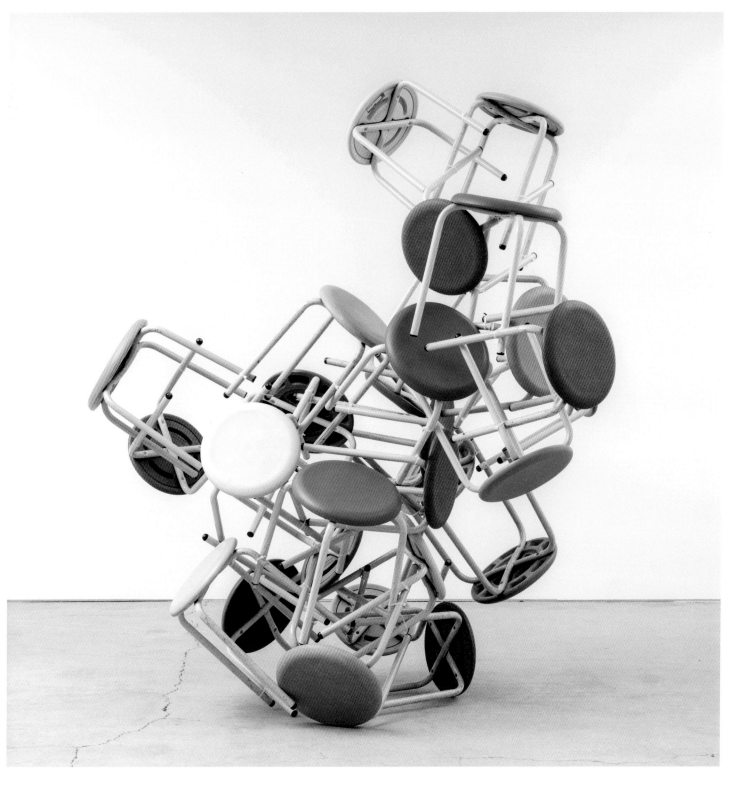

いたずらずきな
イスたちと　あそべば
からだも　こころも
かるくなるはず

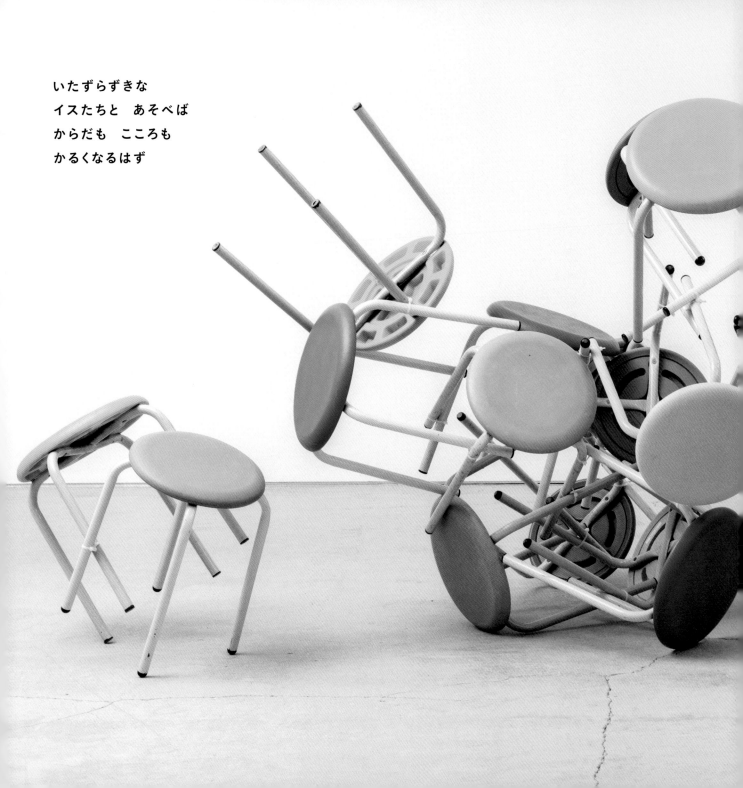

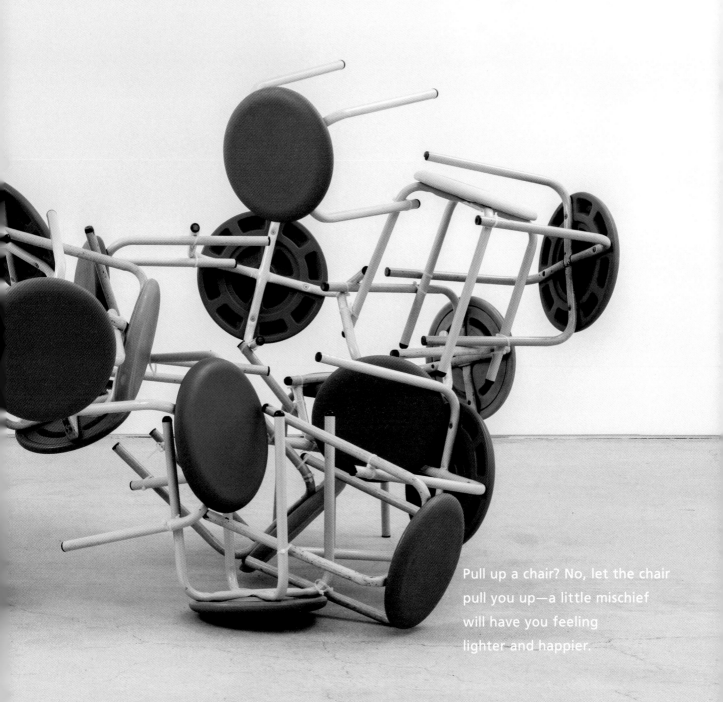

Pull up a chair? No, let the chair pull you up—a little mischief will have you feeling lighter and happier.

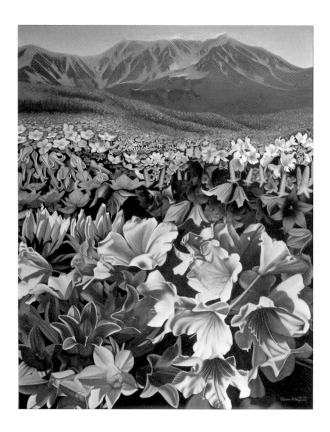

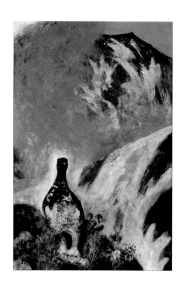

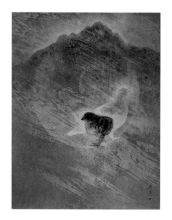

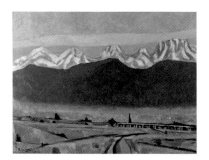

ここに　ならんでいるのは
すべて　とやまけんの　たてやまのえです
いろいろな　たてやまが　あるね
あなたなら　どんなやまを　えがきますか

These are all pictures of
Mt. Tateyama in Toyama Prefecture.
Everyone has their own take on the mountain.
How would you paint yours?

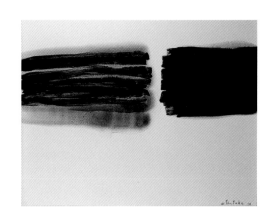

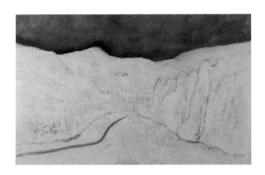

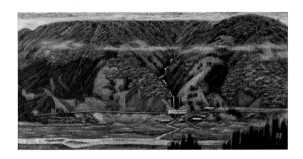

その3　やまのえがならぶ　てんじしつ

みんな　ちがっているから　おもしろい

びじゅつかんに　いくと　たくさんのえが　みられるけれど

みんな　にたりよったりだったら　たいくつで　ねむくなる

おなじ　やまをみても　みんなとちがった　いろや　かたちを　みつけだすことがある

みんなとちがった　きもちや　かんがえが　うかぶこともある

それをあらわすべきだ　げいじゅつには　たすうけつも　ぜんいんいっちも　ふむつよう

そういう　じょうしきはずれが　すてきだと　かんじられたら

そんなときは　ためらわず　じしんをもって

あなたはすでに　げいじゅつの　とびらのまえにたっている

You can see so many pictures at an art museum, but it'd all be a snooze if everything looked the same. When you look at a mountain, you might see different colors and shapes from everyone else. You might not feel the same about it as other people, either. But that doesn't mean you should hide your ideas. Don't hold back. Express yourself. Be different. But that's part of art's allure. In art, there's no need for majority rule or unanimous decisions. It doesn't line up with traditional common sense. If you feel that pull, you're ready to step through the door of art.

Room 3: Mountain imagery

We're all different—and that's what makes us special

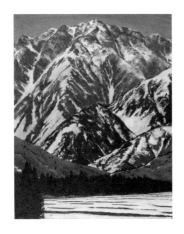

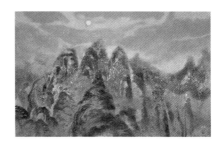

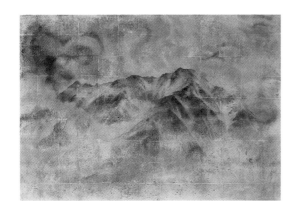

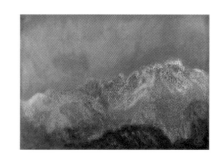

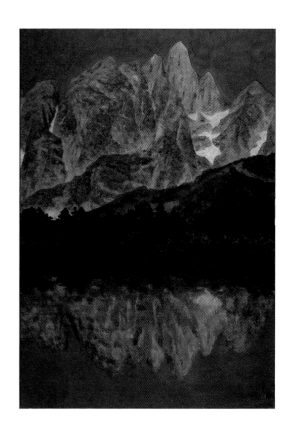

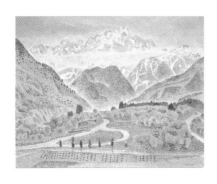

いしころの こえをきく

しじんで　びじゅつひょうろんかの　たきぐちしゅうぞうさんは
だれとでも　あそぶことが　できるひとだった

ひろった　いしころ
すてられた　らくがき
なみにもまれた　かいがら
こわれた　とけい

たきぐちさんが　はなしかけると
いろんなものが　かたりかけてくる
そのこえに　みみをかたむけるのが
たきぐちさんは　すきなんだ

そのきもち　わたしにも　わかるなあ

Listen to the voices of the stones

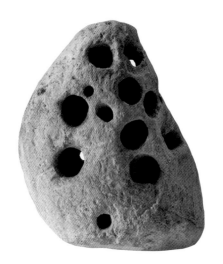

Poet and art critic Takiguchi Shuzo
could play with anyone and anything.

Stones on the ground,
thrown-away doodles,
shells in the ocean waves,
broken clocks.

Whatever Takiguchi talked to,
it was eager to respond.
Takiguchi loved listening
to those voices.

I think I know how he felt.

たきぐちしゅうぞう　コレクション
Takiguchi Shuzo Collection

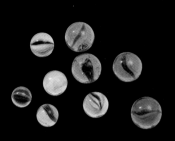 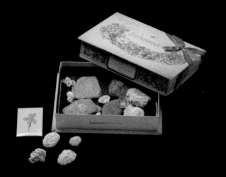

Things　　　　　　　make their way　　　　　　to me

もりむらやすまさ　コレクション
Morimura Yasumasa Collection

 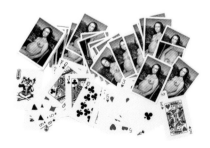

わたしのところには　　　　　いろんなものが　　　　　ながれつく

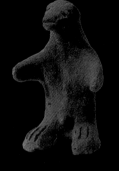

A forlorn face, hidden

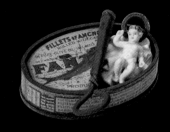

Something emerging

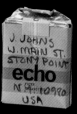

Idle scribbles on a box

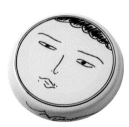

かなしいかおが　かくれている

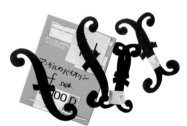

なかから　なにかが　あらわれる

はこのおもてに　らくがきをする

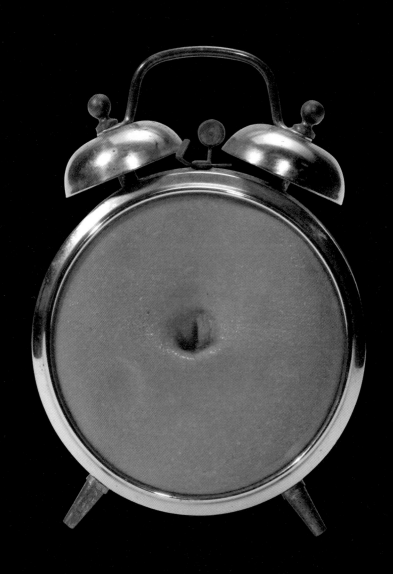

とけいのようで　とけいではない
Like a clock, but not a clock

おさらのようで　おさらではない
Like a plate, but not a plate

A little creepy

ちょっと ぶきみ

Old

cherished memories

むかしの

たいせつな おもいで

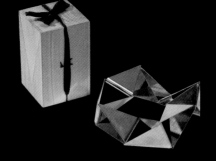

To others,

mysterious curiosities

To me, priceless treasures

たにんには

なぞのぶったい

でも　わたしには　たからもの

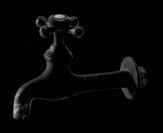

Throw it away,

and

it's gone

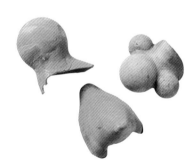

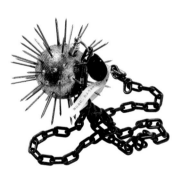

すてれば

それで

おしまい

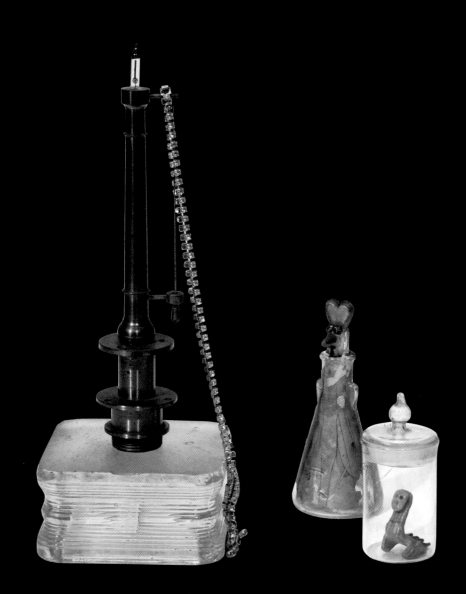

ならべかたによって
Everything depends on

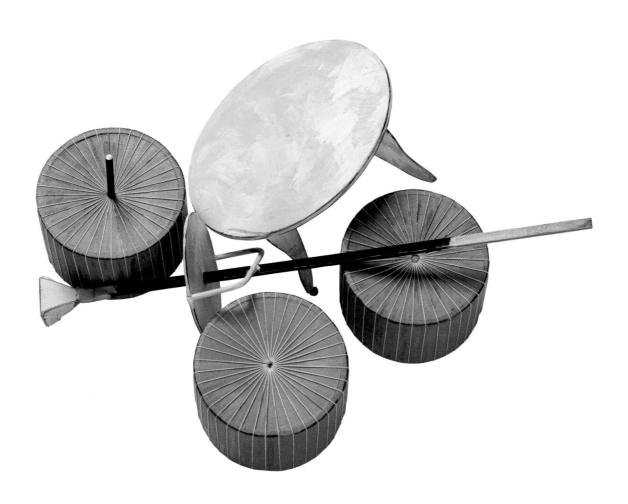

せかいが　ちがってみえる
how you position it

Cute little faces

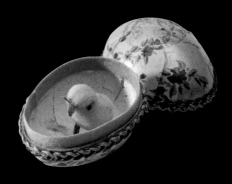

peeking through

ちょっと　めはなを

つけてみる

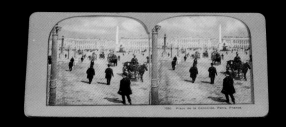

Throw it away? Or pick it up?

Look? Or touch?

すてる　かみあれば

ひろう　かおあり

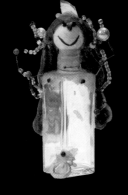

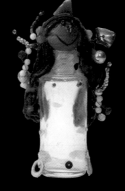
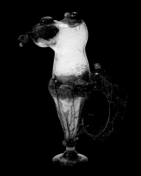

Everything has a face

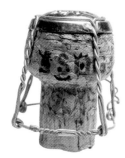
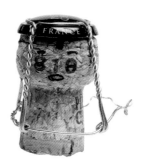
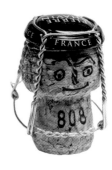

どんな ものにも かおがある

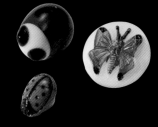

Everything

can be fun

if you want it to be

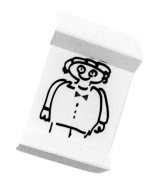

どんなものでも

きもちしだいで

たのしくなってくる

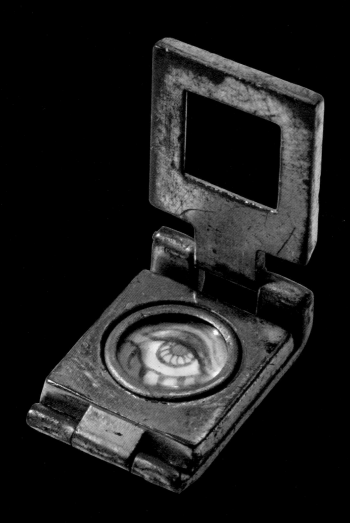

Wow!

わっ!

Another curiosity

またまた なぞの　ぶったい

More and more

mysterious objects

ますます

なぞの　ぶったい

They're all

so weird

and so cool

みんな

へんなやつ

カッコいい

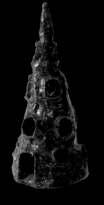

They almost seem like ancient artifacts

They each have their own voice

A distant past meets the future

まるで　きげんぜんの　ほりだしものだ

それぞれに　それぞれの　こえがある

とおくてちかい　みらいに　ひびくかこ

おおきなうちゅうは　ちいさなはこの　なかにある

びじゅつかんという
おおきなはこの　なかには

てんじしつという　またべつの
そこそこ　おおきなはこがあるね

そして　てんじしつには
さくひんというなまえの　ちいさなはこが　ならんでいる

Room 5: Three-dimensional works

A universe in a box

Inside the big "box" of any art museum
are the smaller "boxes" of the exhibition rooms.

And in those exhibition rooms
lie the tiny "boxes" of what we call "works of art."

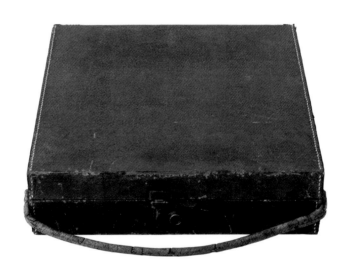

さくひんは　ちっぽけなはこだけど
なかを　のぞきこんでみると
おくがふかくて　はてしなくひろがる
アナザーワールドに　であえるよ

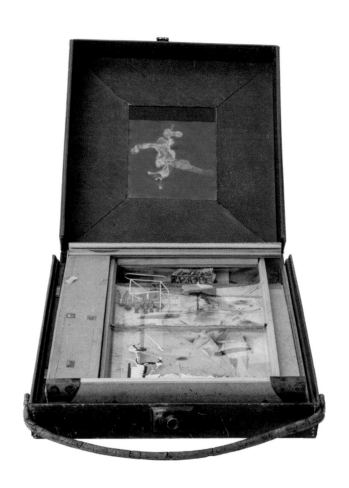

マルセル・デュシャン《トランクの箱》(特装版)1946
Marcel Duchamp, *La boîte en valise (Special version)*, 1946

A piece of artwork might be just a little box,
but a look inside can show you something extraordinary:
another world, a deep, boundless realm to explore.

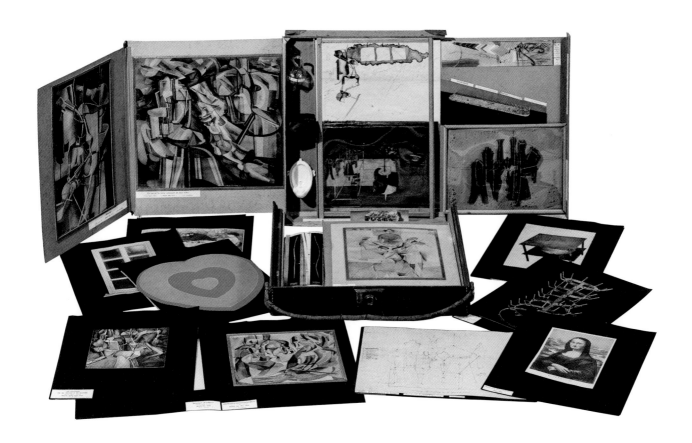

なにがみえるかは
あなたしだい

What you see
is up to you

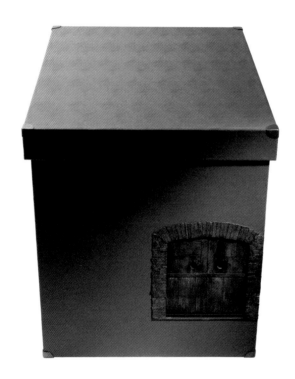

森村泰昌《Du 茶庵》2020
Morimura Yasumasa, *A Japanese Tea House for Marcel Duchamp*, 2020

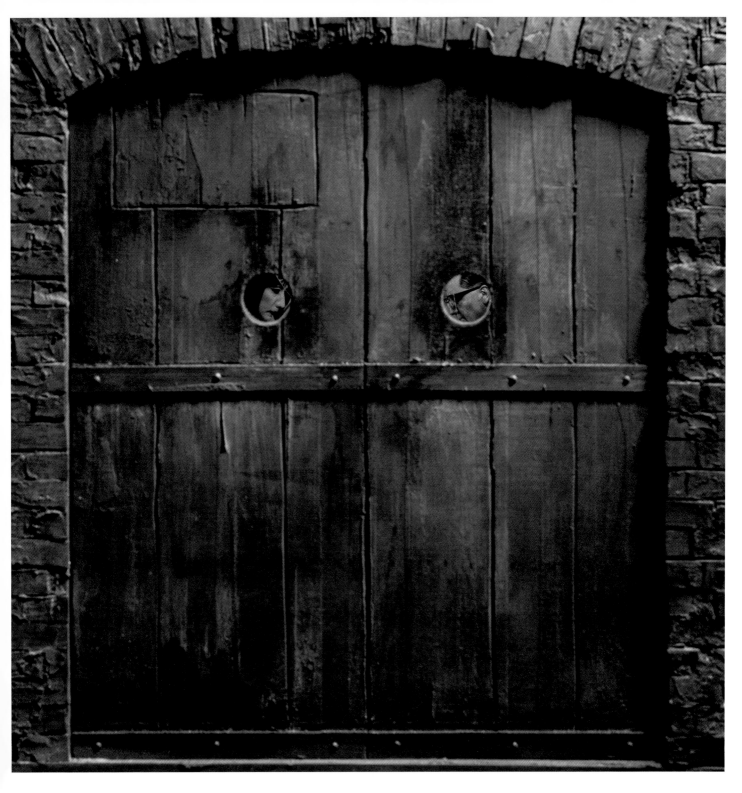

さくひんという　はこのなかには
なんでも　いれられる
なんでも　つくることができる

You can put anything
and create anything
inside the "box" of a work of art.

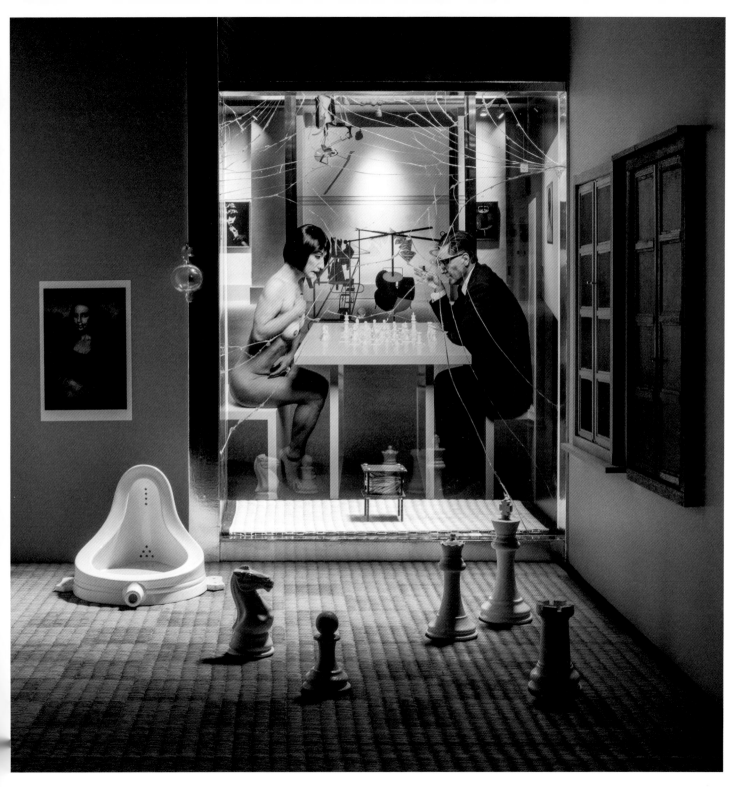

なにをかんじるかは
あなたしだい

What you feel
is up to you

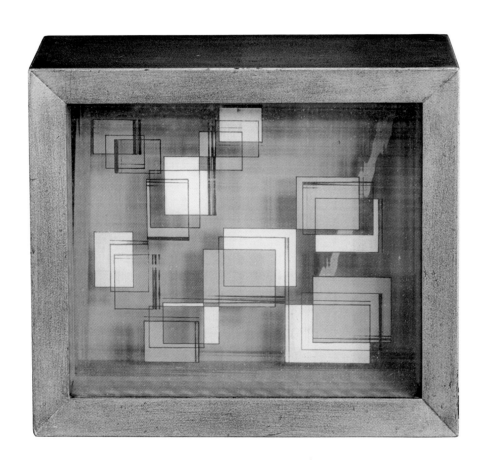

山口勝弘《ヴィトリーヌ　No.1》1952
Yamaguchi Katsuhiro, *Vitrine No.1*, 1952

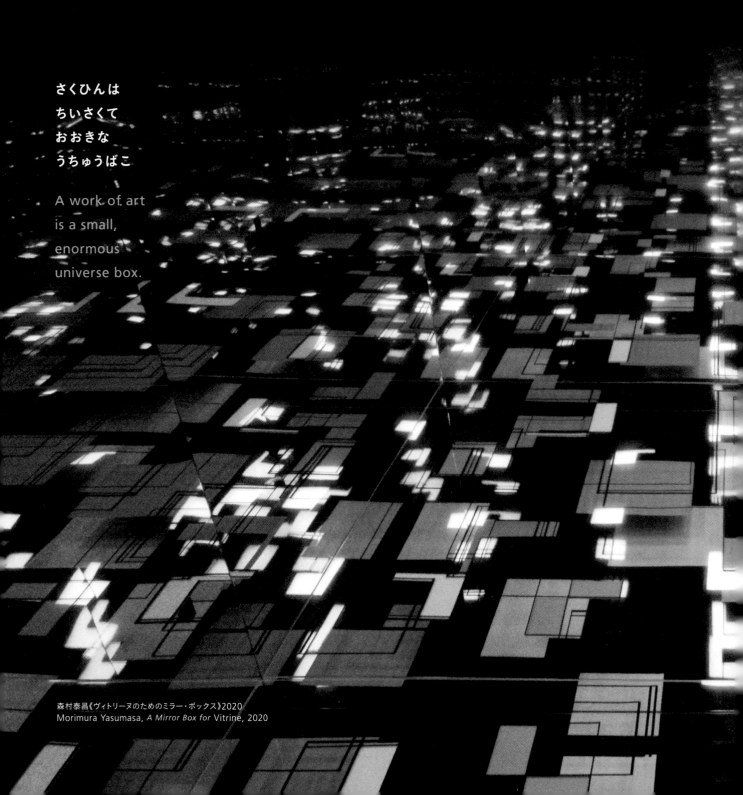

さくひんは
ちいさくて
おおきな
うちゅうばこ

A work of art
is a small,
enormous
universe box.

森村泰昌《ヴィトリーヌのためのミラー・ボックス》2020
Morimura Yasumasa, *A Mirror Box for* Vitrine, 2020

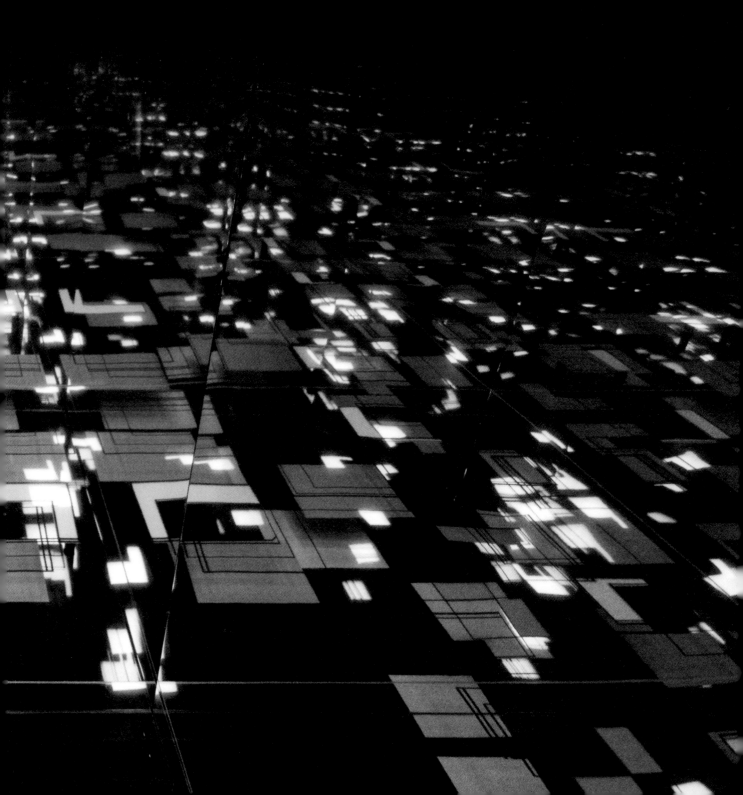

その6　モリムラびじゅつし　はくぶつかん

ほんきでまねると　ほんものになる

こどものころは　ほんきでまねて　ほんきであそんだ
あのころは　なんにでもなれた
そして　いつもひとりで　ドキドキしていた

やがて　わたしは　おとなになった

こどものころなら　なれた
たくさんの「わたし」のことは　わすれ
わたしも　はたらかなくてはならないと　かんがえた
おとなは　あそんでばかりは　いられないからね

でも　あるとき　きがついた
ほんきであそぶことって
ずいぶん　やりがいのある　しごとなんだってことを

Be serious about copying, and you get the real thing

When I was a kid, I was serious about being a copycat
and playing my heart out. I could be anything I wanted to be,
and I loved every minute of it.

But in time, I grew up.

I knew that I had to forget about
all the different versions of "me" that I could be when I was young.
I knew I had to get a job, too.
Grown-ups can't just spend all their time playing, right?

But then I realized:
Being seriously unserious,
serious about playing,
could be a really rewarding job.

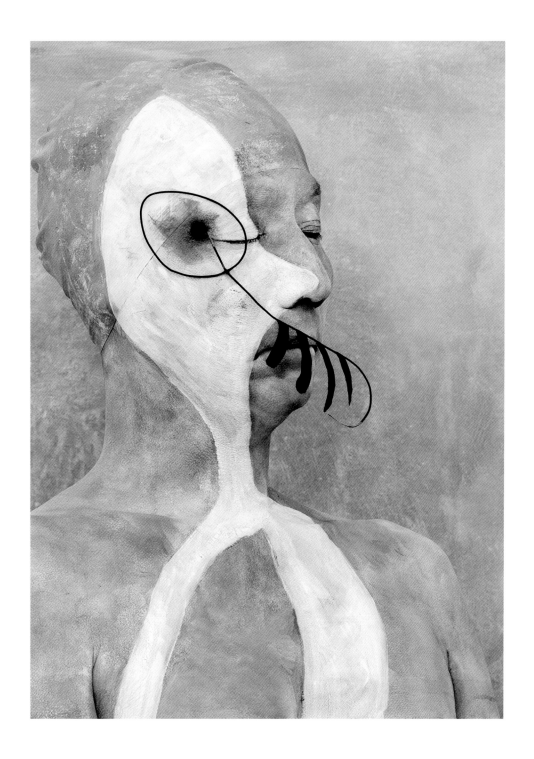

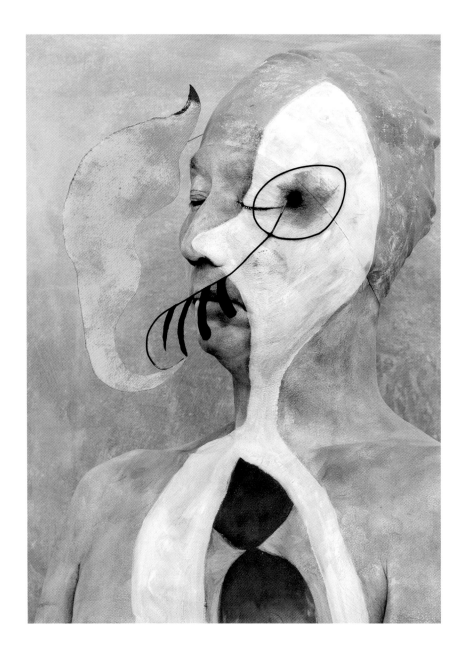

森村泰昌《ほんきであそぶとせかいはかわる（ミロ A）》2020
Morimura Yasumasa, *Want to change the world? Be seriously unserious (Miró A)*, 2020

だから　もういちど
じぶんが　こどもだったころを　おもいだし
ほんきでまねて　ほんきでまなび
ほんもののさくひんをつくろうと　こころにきめたんだ

So I remembered how things were when I was a kid,
when I was serious about copying things and playing my heart out,
and I decided to turn those real joys into real art.

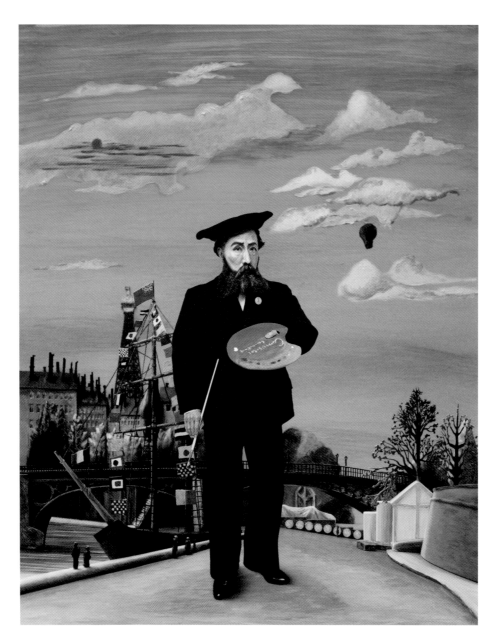

森村泰昌《自画像の美術史（子供のためのアンリ・ルソー）》2016
Morimura Yasumasa, *Self-Portraits through Art History (Henri Rousseau for Children)*, 2016

ルソーおじさんに　なってみる
おもちゃばこに　はいった
きもちになりました

I decided to be Rousseau,
and I felt like I was in a chest full of toys.

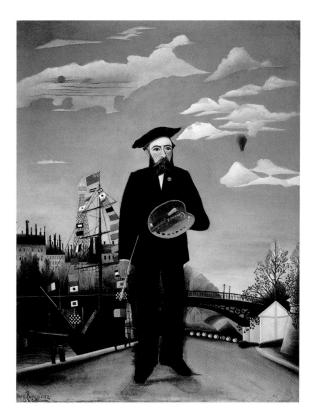

アンリ・ジュリアン・フェリックス・ルソー《私自身、肖像=風景》1890
Henri Julien Félix Rousseau, *Moi-même, Portrait-Paysage*, 1890

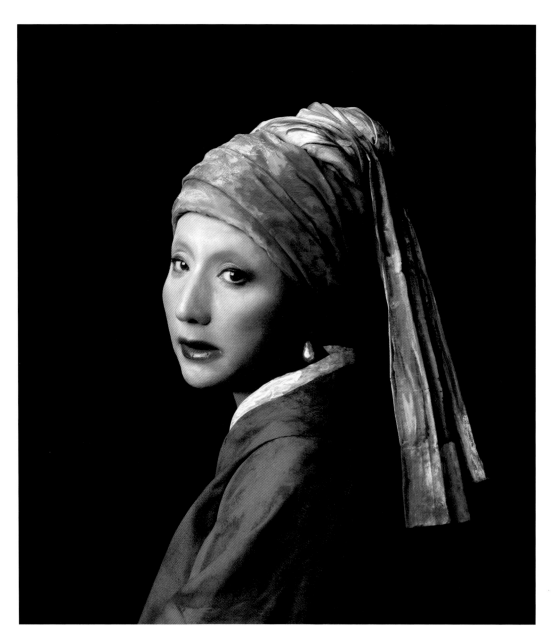

森村泰昌《フェルメール研究（振り向く鏡）》2008
Morimura Yasumasa, *Vermeer Study: Looking Back Mirror,* 2008

フェルメールの　えがく
おんなのこのように
やさしさと　こわさをひめて
ふりむいた

I decided to be Vermeer's girl,
trying to look over my shoulder with that
same blend of gentle warmth and chilly fear.

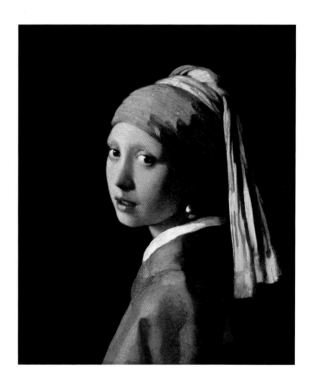

ヨハネス・フェルメール《真珠の耳飾りの少女》1665 頃
Johannes Vermeer, *Girl with a Pearl Earring*, ca.1665

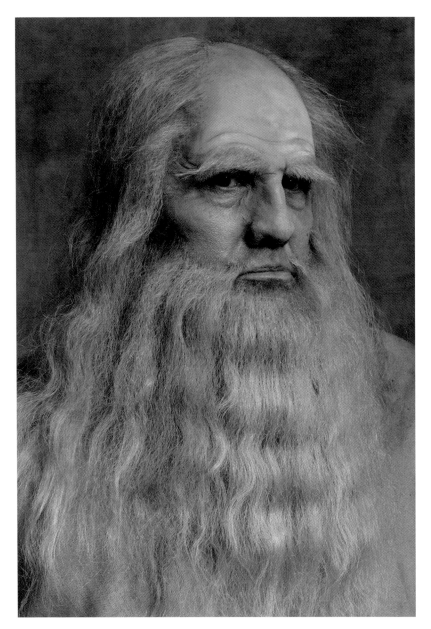

森村泰昌《自画像の美術史（レオナルドの顔が語ること）》2016/2018
Morimura Yasumasa, *Self-Portraits through Art History (What Leonardo's Face Says)*, 2016/2018

ダ・ヴィンチさんに　なってみたら
わたしにも　はつめいや　はっけんが
いっぱいできるかな

I decided to be Da Vinci,
and I felt like I might be able
to think up an invention.

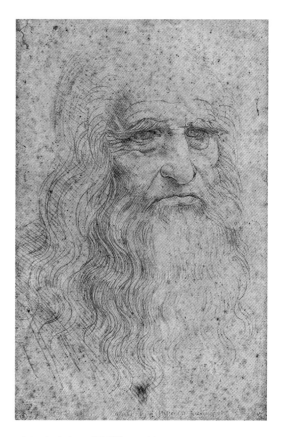

レオナルド・ダ・ヴィンチ《自画像》1490 または 1515−16
Leonardo da Vinci, *Autoritratto*, ca.1490 or 1515−16

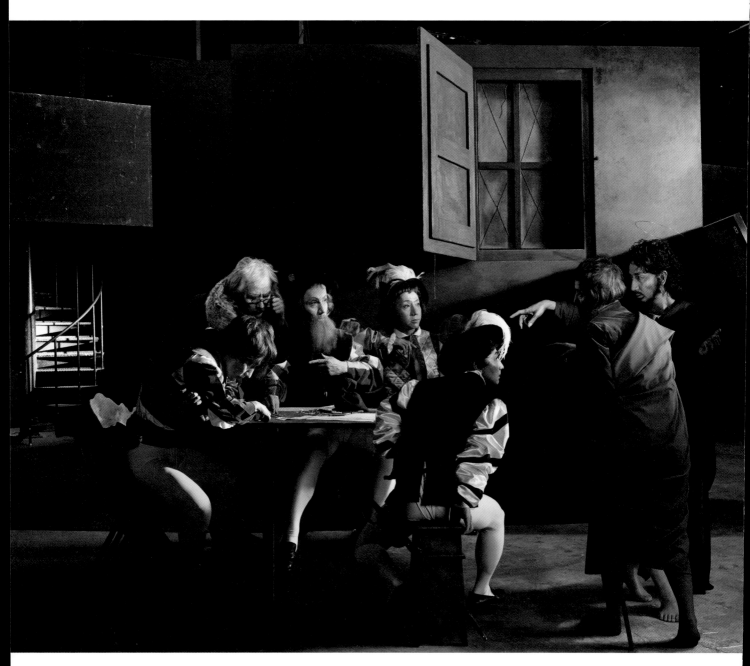

森村泰昌《自画像の美術史（カラヴァッジョ／マタイとは何者か）》2016
Morimura Yasumasa, *Self-Portraits through Art History (Caravaggio / Who Is Matthew?)*, 2016

7にんの　とうじょうじんぶつに
すべてひとりで　なりきってみた
わたしのなかには
たくさんのわたしが　いきている

I decided to be all seven
people in Caravaggio's famous scene.
Am I "me?" Or am I "us?"

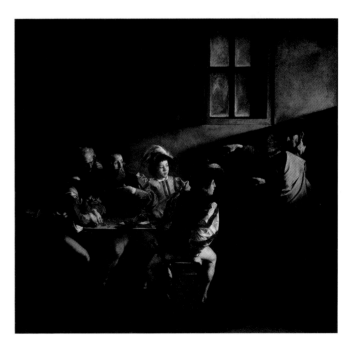

ミケランジェロ・メリージ・ダ・カラヴァッジョ《聖マタイの召命》1600頃
Michelangelo Merisi da Caravaggio, *La Vocazione di San Matteo*, ca. 1600

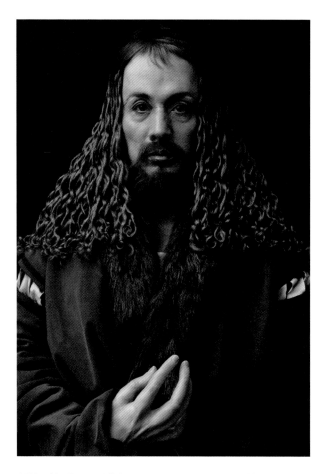

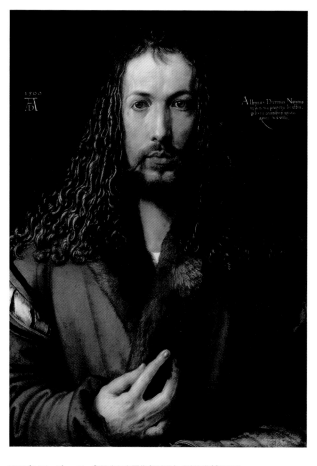

森村泰昌《自画像の美術史（デューラーの手は、もうひとつの顔である）》2016/2018
Morimura Yasumasa, *Self-Portraits through Art History
(Dürer's Hand Is Another Face)*, 2016/2018

アルブレヒト・デューラー《28歳の自画像（1500年の自画像）》1500
Albrecht Dürer, *Self-Portraits at 28*, 1500

デューラーさんに　なって
どんなものにも　まけない
つよいきもちを　かちとろう

It's amazing who you can be.
Be Dürer, and feel unstoppable.

ファン・エイクさんに　なって
どんなちいさな　へんかも
みおとさない　ひとになろう

Be Van Eyck, and hone
a sharper eye for the tiniest details.

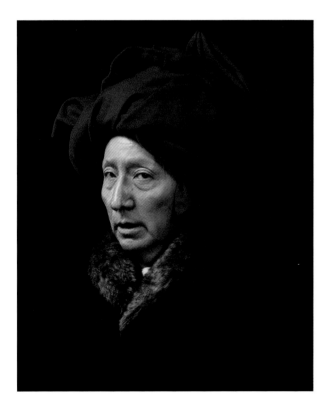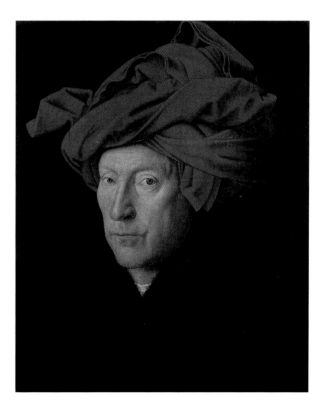

森村泰昌《自画像の美術史（赤いターバンのファン・エイク）》2016/2018
Morimura Yasumasa, *Self-Portraits through Art History*
(Van Eyck in a Red Turban), 2016/2018

ヤン・ファン・エイク《ターバンの男の肖像》1433
Jan Van Eyck, *Portrait of a Man (Self Portrait?)*, 1433

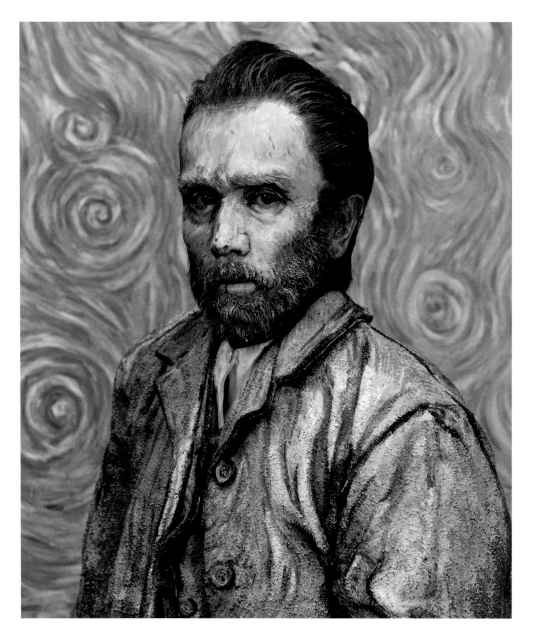

森村泰昌《自画像の美術史（ゴッホ／青）》2016
Morimura Yasumasa, *Self-Portraits through Art History (Van Gogh / Blue)*, 2016

ゴッホさんの
がんばり　まじめさ　かなしみ
つらぬきとおすきもち　しんじるちから
がまんするにぎりこぶしを　わかちあおう

Be Van Gogh, and feel his determination,
his sincerity, his sadness; share his commitment to following through,
his will to believe, his fortitude to withstand whatever comes along.

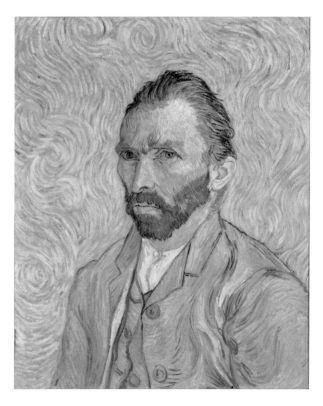

フィンセント・ファン・ゴッホ《自画像（渦巻く青い背景の中の自画像）》1889
Vincent Van Gogh, *Self-Portrait*, 1889

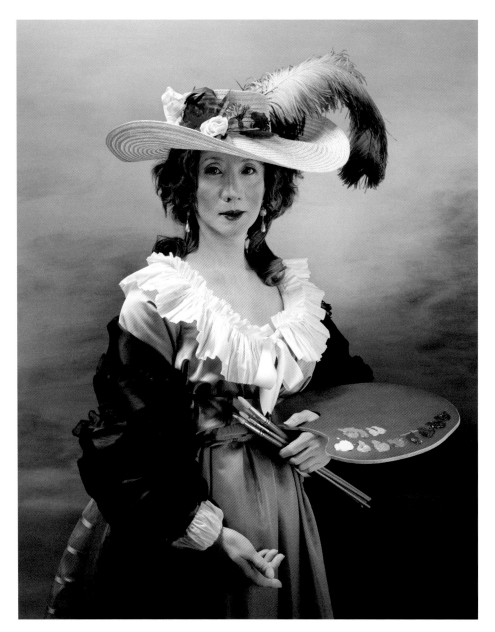

森村泰昌《自画像の美術史（証言台に立つブラン）》2016
Morimura Yasumasa, *Self-Portraits through Art History (Le Brun on the Witness Stand)*, 2016

なにかに　たちむかう
つよいきもちが　あなたを　うつくしくする
でも　ゆうがさを　わすれると　かがやかない

Determination is a beautiful thing.
Embracing a challenge makes you an even more beautiful person.
But without a little grace, that beauty might not shine through.

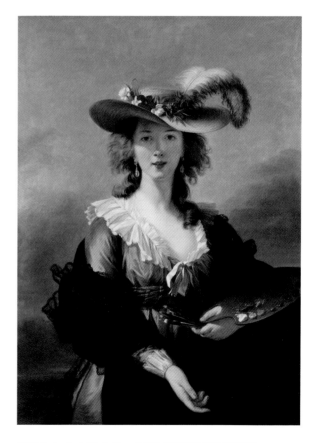

エリザベート＝ルイーズ・ヴィジェ＝ルブラン《麦藁帽子の自画像》1782
Élisabeth Louise Vigée Le Brun, *Self Portrait in a Straw Hat*, 1782

ほんきでまねて　ほんきでまなび
ほんものの　さくひんを　つくりたい

I want to make real art
out of serious copying and serious fun.

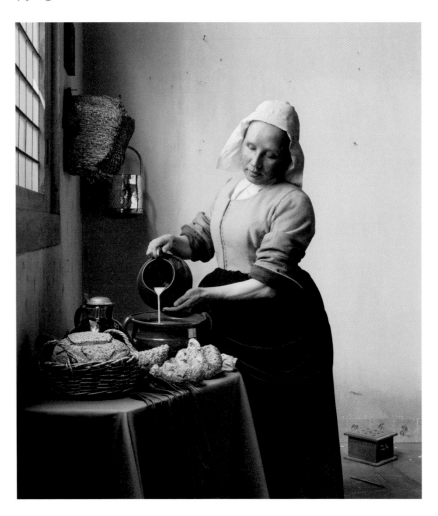

森村泰昌《フェルメール研究（わが町に何を注ぐか）》2019
Morimura Yasumasa, *Vermeer Study: What to Pour into My Town*, 2019

ほんきでまねて　まなぶこと
それは　だれにでも　できることだから
みなさんも　やってみてください

Anyone can put their mind
to copying and playing.
Why not have a go at it yourself?

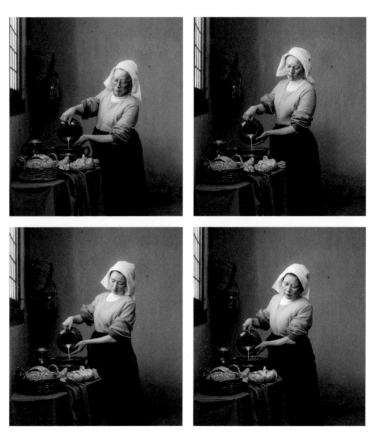

「モリメール写真館」より 2019
左上より時計回りに、和田大象さん、吉村睦人さん、吉田恵子さん、大貫正恵さん

From *Morimeer Photo Studio*, 2019
Clockwise from top left: Mr. Wada Taizoo, Mr. Yoshimura Mutsuhito,
Ms. Yoshida Keiko and Ms. Onuki Masae

まねること　だけでなく
どんなことでも　そうだけど
てきとうは　ダメなんだ

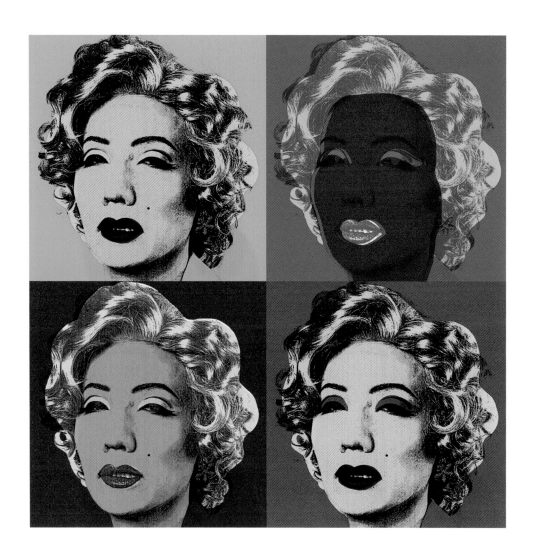

森村泰昌《もうひとつのマリリン》2015
Morimura Yasumasa, *Another Marilyn*, 2015

It's not just about copying, though.
Whatever you do, never do it halfway.
Be serious about it.

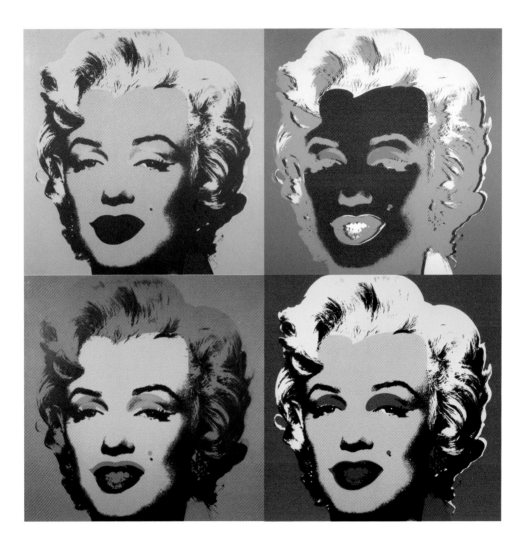

アンディ・ウォーホル《マリリン》1967
Andy Warhol, *Marilyn*, 1967

あなたのほんきが　せかいを　かえる
ほんきでわたしは　そうおもう

When you're serious about something,
you can change the world.
I'm serious about that.

森村泰昌《ほんきであそぶとせかいはかわる（ミロ B）》2020
Morimura Yasumasa, *Want to change the world? Be seriously unserious (Miró B)*, 2020

あとがき

びじゅつかんにいったとき、さくひんとどんなふうに、むきあったらいいのだろう。
そんなみなさんのぎもんを、たいせつにうけとめて、このほんをつくりました。

わたしは、びじゅつさくひんと、あそびたいとおもいました。
よのなかには、いろいろなあそびがありますね。
でも、びじゅつさくひんとのあそびかたが、かたられることはすくないです。
だったら、あたらしいあそびかたをかんがえてみたいと、おもったのです。

ぜんぶで6しゅるいの、あそびかたをかんがえました。
へえ、そんなことしていいの？　そんなみかたをしていいの？
そんな、へんてこりんなあそびかたばかりです。

へんてこりん？　でもそれは、いいかえると、ぼうけんのたびに、でることでも、あるんですね。
なんだかよくわからないから、へんてこりんにかんじられる。
しかし、へんてこりんで、よくわからないから、ハラハラとドキドキがやってくる。
そのときめきが、ぼうけんのこころなんです。

びじゅつかんしょうを、ハラハラとドキドキがあふれる、へんてこりんなあそびにおきかえて、
ほんきで、このぼうけんとつきあってみたい。わたしは、ずっとそうおもっています。

このほんをつくるにあたり、とやまけんびじゅつかんの、
とてもおもしろいコレクションのかずかずを、つかわせていただきました。
このほんをよみおわったら、ぜひ、じっさいにびじゅつかんにいって、
さくひんとむきあい、かたりあい、こんどは、あなたじしんのやりかたで、ほんきであそんでみてください。

さくひんたちは、あなたがあそびにくることを、ずっとまっています。

びじゅつか　もりむら やすまさ

Afterword

When you go to an art museum, how are you supposed to approach what you see? It's a question that crosses everyone's mind, I think, and it's an important one. It's what led me to create this book.

For me, art has always been something I want to play with. The world is full of different ways to play. But you don't hear too many people talking about how to play with art. Well, I thought, maybe I could think up a new way to play.

I eventually came up with six ways to play with art. When you try them out, you might feel hesitant at first. You might ask yourself, "Can I really do this?" "Is it really OK to look at artwork this way?" All the ideas are a little weird, a bit off the beaten path.

Why would you want to try something like that? The answer's simple: going off the beaten path is how adventures begin.

A new idea feels weird because you can't make sense of it. It's unfamiliar—but that also means it's exciting. Your heart beats a little faster; the air buzzes with anticipation. That's what an adventure feels like. For as long as I can remember, I've wanted to make the experience of art into an adventure: a thrilling encounter, full of the playful, the weird, the unconventional.

This book tries to capture that feeling. I wouldn't have been able to make it without the help of Toyama Prefectural Museum of Art & Design, which gave me access to a collection that was perfect for inspiring adventures.

After you've read the book, I hope you go on your own adventure. Head to an art museum. Encounter the works. Commune with the works. Play with the works however you want to. Just remember to be mindful about it: seriously unserious.

The art is there for you to enjoy—and the works have been waiting for you to come and have some fun.

Morimura Yasumasa
Artist

作品リスト List of Works

特記された作品以外は富山県美術館の所蔵作品です。
All works are from the collection of Toyama Prefectural Museum of Art and Design unless otherwise noted.

その1 かいがの てんじしつ ひっくりかえす　　Room 1: Paintings　Turn it around

頁 Pages	作品 Works	寸法 Dimensions
009-010	ルーチョ・フォンタナ《空間概念——期待》1962　キャンバスに水溶性絵具 Lucio Fontana, *Concetto spaziale—Attese*, 1962, watercolor on canvas © Lucio Fontana by SIAE 2020 G2107	91.5× 73.0 cm
012-013	ジャクスン・ポロック《無題》1946　メゾナイト板に油絵具、エナメル、新聞紙、コラージュ Jackson Pollock, *Untitled*, 1946, oil, enamel and newspaper collage on masonite board	60.5× 48.0 cm
014-015	ジョルジュ・ルオー《パシオン》1943　キャンバスに油絵具 Georges Rouault, *Passion*, 1943, oil on canvas © ADAGP, Paris & JASPAR, Tokyo, 2020 G2107	104.0× 73.5 cm
016-017	ジョセフ・コーネル《ホテル・フローレンス（ペニー・アーケード・シリーズ）》1960年代半ば　ボードにコラージュ Joseph Cornell, *Hotel Florence (Penny Arcade Series)*, Mid 1960s, collage on boad © The Joseph and Robert Cornell Memorial Foundation/VAGA at ARS, NY/JASPAR, Tokyo, 2020 G2107	29.2× 39.4 cm
018-019	ジャスパー・ジョーンズ《消失II》1961　キャンバスに油絵具、アンコスティック、コラージュ Jasper Johns, *Disappearance II*, 1961, oil and encaustic on canvas and collaged canvas © Jasper Johns/VAGA at ARS, NY/JASPAR, Tokyo, 2020 G2107	101.6× 101.6 cm
020-021	ゲルハルト・リヒター《オランジェリー》1982　キャンバスに油絵具 Gerhard Richter, *Orangerie*, 1982, oil on canvas © Gerhard Richter 2019 (11122019)	260.0× 400.0 cm
022-023	フランク・ステラ《タラデガ》1981　アルミニウムハニカムに油絵具、オイルバー他 Frank Stella, *Talladega*, 1981, oil and oilstick etc. on etched aluminium honeycomb © 2020 Frank Stella/ARS, New York/JASPAR, Tokyo G2107	191.0× 207.0× 35.6 cm
028-029	トム・ウェッセルマン《スモーカー #26》1978　キャンバスに油絵具 Tom Wesselmann, *Smoker #26*, 1978, oil on canvas © Estate of Tom Wesselmann/VAGA at ARS, NY/JASPAR, Tokyo, 2020 G2107	243.8× 269.2 cm
030-031	アントニ・タピエス《ちいさな木とひも》1973　キャンバス材、木板に紐、油絵具 Antoni Tàpies, *Petit boi et corde*, 1973, oil and string on stretcher and wooden panel © Comissió Tàpies, JASPAR, Tokyo, VEGAP, Madrid, 2020 G2107	46.5× 38.0 cm

その2 イスの てんじしつ いたずらも たまにはちょっと やるといい　　Room 2: Chairs　A little mischief never hurt anyone

頁 Pages	作品 Works	寸法 Dimensions
034-035	森村泰昌《イームズチェアがおどるとき》2020　椅子、鉄　作家蔵　制作：田中之博　撮影：福永一夫 Morimura Yasumasa, *Dancing Eames Chair*, 2020, chairs, steels, Collection of the artist Production: Tanaka Yukihiro, Photo: Fukunaga Kazuo	46.5× 55.0× 41.0 cm each
	チャールズ＆レイ・イームズ《イームズシェルサイドチェア》デザイン：1950-53 Charles & Ray Eames, *Eames Molded Fiberglass Chair*, d.1950-53	46.5× 55.0× 41.0 cm
036-037	森村泰昌《バタフライ・スツールがとびまわる》2020　インスタレーション　作家蔵　制作：田中之博、井野敬裕、松本和史　撮影：福永一夫　撮影協力：CCO クリエイティブセンター大阪、天童木工 Morimura Yasumasa, *Fluttering Butterfly Stools*, 2020, Installation, Collection of the artist, Production: Tanaka Yukihiro, Ino Takahiro, Matsumoto Kazuhito Photo: Fukunaga Kazuo, In cooperation with Creative center OSAKA, TENDO.CO.,LTD., Courtesy of YANAGI DESIGN OFFICE	—
	柳宗理《バタフライ・スツール》デザイン：1956　ローズウッド材成型合板、銅 Yanagi Sori, *Butterfly Stool*, d.1956, laminated rosewood plywood, brass	39.5× 42.0× 31.0 cm
038-039	森村泰昌《リートフェルトはロボットである》2020　椅子、木材、塗料　作家蔵　制作：田中之博　撮影：福永一夫 Morimura Yasumasa, *Rietveld Meets Robot*, 2020, chairs, woods and paint, Collection of the artist, Production: Tanaka Yukihiro Photo: Fukunaga Kazuo	134.0× 57.0× 53.0 cm
040-041	森村泰昌《リートフェルトにすわるにんげんはロボットになる》2020　パフォーマンス　衣装：邨田雄生実　撮影：森田兼次　撮影協力：埼玉県立近代美術館 Morimura Yasumasa, *Rietveld Meets Robot Meets Person*, 2020, Performance、Costume: Murata Oumi, Photo: Morita Kenji, In cooperation with The Museum of Modern Art, Saitama	—

頁 Pages	作品 Works	寸法 Dimensions
039-041	ヘリット・トマス・リートフェルト《レッド・アンド・ブルー》デザイン：1918-23（製造：1990年代）ブナ材、塗装仕上げ Gerrit Thomas Rietveld, *Red and Blue*, d.1918–23 (production: 1990s), beech wood, dyed and painted finish	88.0× 65.5× 83.0 cm
042-045	森村泰昌《バラいろのじんせい（ミス・ブランチ）》2020　インスタレーション　撮影：福永一夫 Morimura Yasumasa, *La Vie en Rose (Miss Blanche)*, 2020, Installation, Photo: Fukunaga Kazuo	—
	倉俣史朗《ミス・ブランチ》デザイン：1988（製造：1994 頃）　アクリル、造花のバラ、アルミニウムパイプ（アルマイト染色仕上） Kuramata Shiro, *Miss Blanche*, d.1988 (production: ca.1994), acrylic, artificial roses, aluminium pipe with stained alumite finish	87.5× 62.0× 60.0 cm
046-049	森村泰昌《イスのサーカス》2020　インスタレーション　作家蔵　撮影：福永一夫 Morimura Yasumasa, *Chair Circus*, 2020, Installation, Collection of the artist, Photo: Fukunaga Kazuo	—

その3　やまのえがならぶ　てんじしつ　みんな　ちがっているから　おもしろい　Room 3: Mountain imagery　We're all different—and that's what makes us special

頁 Pages	作品 Works	寸法 Dimensions
051 右上より 時計回りに表記 Clockwise from top right	津高和一《気―立山にて》1978　キャンバスに油絵具 Tsutaka Waichi, *Atmosphere—At Mt. Tateyama*, 1978, oil on canvas	112.1× 145.5 cm
	鴫剛《2004.5.6.16:00》2004　キャンバスに油絵具 Shigi Go, *2004.5.6.16:00*, 2004, oil on canvas	89.5× 145.6 cm
	今野忠一《称名滝》1982　和紙に岩絵具 Konno Chuichi, *Shomyodaki Fall*, 1982, natural mineral pigment on Japanese paper	130.3× 89.4 cm
	小泉淳作《常願寺川》1982　和紙に岩絵具 Koizumi Junsaku, *Jōganjigawa River*, 1982, natural mineral pigment on Japanese paper	82.0× 167.0 cm
	田村一男《白い道》1981　キャンバスに油絵具 Tamura Kazuo, *White Road*, 1981, oil on canvas	89.5× 145.5 cm
052 左上より 時計回りに表記 Clockwise from top left	北山泰斗《立山幻想》1979　キャンバスに油絵具 Kitayama Taito, *Fantasy of Mt. Tateyama*, 1979, oil on canvas	227.2× 182.0 cm
	清原啓一《雷鳥》1982　キャンバスに油絵具 Kiyohara Keiichi, *Grouse*, 1982, oil on canvas	145.5× 97.4 cm
	下田義寛《山の朝》1983　和紙に岩絵具 Shimoda Yoshihiro, *Morning of a Mountain*, 1983, natural mineral pigment on Japanese paper	116.7× 90.9 cm
	片岡球子《立山》1983　和紙に岩絵具 Kataoka Tamako, *Mt. Tateyama*, 1983, natural mineral pigment on Japanese paper	80.3× 116.7 cm
	矢橋六郎《連峰初冬》1980　キャンバスに油絵具 Yabashi Rokuro, *Mountain Range in early Winter*, 1980, oil on canvas	97.0× 130.3 cm
053 左上より 時計回りに表記 Clockwise from top left	中島千波《立山》1982　和紙に岩絵具 Nakajima Chinami, *Mt. Tateyama*, natural mineral pigment on Japanese paper	110.8× 161.0 cm
	小野末《剣岳》1979　キャンバスに油絵具 Ono Sue, *Mt. Tsurugidake*, 1979, oil on canvas	84.6× 116.7 cm
	奥田元宋《剣》1966　和紙に岩絵具 Okuda Genso, *Mount Tsurugi*, 1966, natural mineral pigment on Japanese paper	226.0× 157.0 cm
	高田誠《剣岳》1979　キャンバスに油絵具 Takada Makoto, *Mt. Tsurugidake*, 1979, oil on canvas	90.9× 116.7 cm

頁 Pages	作品 Works	寸法 Dimensions
053	畠中光享《朝暉》1983 綿布に岩絵具 Hatanaka Kokyo, *Brilliancy in the Morning*, 1983, natural mineral pigment on cotton cloth	112.1× 162.1 cm
054 左上より 時計回りに表記 Clockwise from top left	相原求一朗《剣岳早春》1980 キャンバスに油絵具 Aihara Kyuichiro, *Mt. Tsurugidake in early Spring*, 1980, oil on canvas	162.1× 130.3 cm
	大野俊明《白銀の峰》2004 麻紙に岩絵具、水彩絵具、墨 Ono Toshiaki, *Silver Peak*, 2004, natural mineral pigment, watercolor and Japanese ink on hemp paper	80.3× 116.7 cm
	橋本龍美《越中倶界波濤之図》1981 和紙に岩絵具 Hashimoto Ryumi, *Picture of the God of Fire's World with Waves in Etchu*, 1981, natural mineral pigment on Japanese paper	146.0× 97.0 cm
	山岸純《霰韻黒部》1982 和紙に岩絵具 Yamagishi Jun, *Hailing Kurobe*, 1982, natural mineral pigment on Japanese paper	74.8× 119.0 cm
	岩橋英遠《北陸路五月に入る》1981 和紙に岩絵具 Iwahashi Eien, *Hokuriku District in May*, 1981, natural mineral pigment on Japanese paper	82.4× 119.0 cm
	司修《雪女》1981 キャンバスに油絵具 Tsukasa Osamu, *Snow Fairy*, 1981, oil on canvas	163.0× 98.5 cm
	麻田鷹司《立山》1982 和紙に岩絵具 Asada Takashi, *Mt. Tateyama*, 1982, natural mineral pigment on Japanese paper © Teruko Asada 2020/JAA2000004	80.4× 117.0 cm

その4 オブジェの てんじしつ いしころの こえをきく　Room 4: Objets d' art　Listen to the voices of the stones

◆ たきぐちしゅうぞう コレクション Takiguchi Shuzo collection

頁 Pages	作品 Works	寸法 Dimensions
059	石／山口勝弘からの贈り物 石 Stones/Gift from Yamaguchi Katsuhiro, stone	16.0× 11.0× 6.0 cm
060 左 Left	フィレンツェで取得したビー玉 1958 採集 ビー玉 Glass marble obtained in Florence, collected 1958, glass marbles	φ1.5- 2.5 cm each
060 中央 Middle	《Souvenirs de Cadaqués(カダケスの記念品)》1958 採集 箱、石8個、貝殻12個、押し花 Takiguchi Shuzo, *Souvenirs de Cadaqués*, collected 1958, box, 8 stones, 12 sea shells, pressed flowers	Box: 4.5× 21.0×15.2 cm
060 右 Right	ポーカーマシン(玩具) プラスチック Poker Machine (toy), plastic	14.3× 14.6× 4.8 cm
061 左 Left	熊形のテラコッタ テラコッタ Bear-shaped Terracotta, terracotta	12.0× 8.0× 5.0 cm
061 中央 Middle	合田佐和子《天使の缶詰》1969 瀬戸物の人形、空缶 Goda Sawako, *Angel in a Can*, 1969, ceramic doll, empty can © Sawako Goda	7.0× 8.3× 3.5 cm
061 右(左・右) Right(Left, Right)	瀧口修造 エコー(煙草の箱)のオブジェ 金属、プラスチック Takiguchi Shuzo, Echo (cigarette box) Object, metal, plastic　　ジャスパー・ジョーンズ エコー(煙草の箱) 1966頃 紙箱に墨 Jasper Johns, Echo (cigarette box), ca.1966, ink on paper box	7.8×5.8×2.2 cm 8.0×6.2×2.3 cm
062	へそ時計 プラスチック、金属 Bellybutton Clock, plastic, metal	13.5× 9.5× 4.0 cm
064 左 Left	爬虫類の革製ケース 爬虫類の革、草 Reptile Leather Case, reptile leather, grass	11.5× 4.2× 1.2 cm
064 右 Right	合田佐和子《イトルビ(女の顔)》1969 紙粘土、アクリル絵具、クリアラッカー Goda Sawako, *Iturbi (A Woman's Head)*, 1969, paper clay, acrylic, transparen lacquer © Sawako Goda	13.5× 7.0× 10.5 cm

頁 Pages	作品 Works	寸法 Dimensions
065 左 Left	田中敦子 油彩 制作年不詳 紙に油絵具 Tanaka Atsuko, Oils, year unknown, oil on paper	5.0× 10.5 cm
065 右 Right	藤松博《滝口さん》1969 紙にインク Fujimatsu Hiroshi, *Mr. Takiguchi*, 1969, ink on paper	27.0× 18.8 cm
066 左 Left	福田繁雄《かたつむりの筆立て》1965 銅板 Fukuda Shigeo, *Snail-shaped Pen Stand*, 1965, copper plate	10.5× φ10.1 cm
066 中央 Middle	中西夏之《The Second Portrait of Shuzo Takiguchi》1969 木、ガラス、金属玉、水銀、針金 Nakanishi Natsuyuki, *The Second Portrait of Shuzo Takiguchi*, 1969 wood, glass, metal balls, mercury, wire © Natsuyuki Nakanishi	18.0× 12.0× 2.5 cm
066 右 Right	三木敏弘《701》制作年不詳 アルミニウム、木製ケース Miki Toshihiro, *701*, year unknown, aluminium, wooden case	5.0× 5.0× 14.0 cm
067 左 Left	モナリザのカフスボタン 金属 Mona Lisa's Cufflinks, metal	2.5× 1.9 cm each
067 中央 Middle	蛇口 錫 Tap, tin	10.0× 14.0× 5.0 cm
067 右 Right	伊藤隆康 アルミのオブジェ 制作年不詳 アルミニウム Ito Takayasu, Aluminium object, year unknown, aluminium	19.3× φ18.0 cm
068	合田佐和子《メケ・メケ》1963 真鍮、ガラス、瓶、ネックレス、恐竜の作り物 Goda Sawako, *Meke Meke*, 1963, brass, glass, bottle, necklace, dinosaur figurine © Sawako Goda	—
070 左 Left	アリスとディートリヒのモノクローム写真 写真、額 Monochrome Photograph of Alice and Dietrich, photographs, frame	11.9× 5.8 cm
070 右 Right	ヒヨコの入った小卵 卵の殻、紙、モール製のヒヨコ Small Egg with Chick, egg shell, paper, chick made out of papermall	6.5× 2.5 cm
071 左 Left	中辻悦子《ポコピン》1963 布、羽毛、ビーズ Nakatsuji Etsuko, *Pokopin*, 1963, cloth, feathers, beads	24.0× 6.0× 3.5 cm
071 右 Right	立体視のカード 紙に印刷 Stereoscopic Card, prints on paper	9.0× 18.0 cm
072 左・中央 Left, Middle	合田佐和子《黄色の侍女》《赤の侍女》1962頃 ガラス、木の浮き、蝋、毛糸 Goda Sawako, *Yellow Maid, Red Maid*, ca.1962, glass, wooden float, wax, yarn © Sawako Goda	10.5×4.0×4.0 cm 9.8×5.0×3.5 cm
072 右 Right	合田佐和子《八月の王》1963 木の浮き、ガラス、銅線、蝋、クリアラッカー Goda Sawako, *The King of August*, 1963, wooden float, glass, copper wire, wax, transparent lacquer © Sawako Goda	28.5× 21.5× 9.5 cm
073 左 Left	アリスのパズルと煙草の巻紙（イタリア製） 紙、ガラス、装飾玉 Alice's Puzzle and a Rolled Cigarrete(made in Italy), paper, glass, decorative beads	6.7× 8.7× 2.9 cm
073 中央 Middle	Tender Buttons 1973採集 プラスチック、金属 Tender Buttons, collected 1973, plastic, metal	—
073 右 Right	バッジ ボール紙、ピン Badge, cardboard paper, pin	φ7.3× 0.7 cm
074	合田佐和子《眼》1966頃 金属、ガラス、アクリル絵具 Goda Sawako, *Eye*, ca.1966, metal, glass, arcrylic © Sawako Goda	3.1× 2.3× 0.9 cm
076 左 Left	荒川修作《Subject/and/subjects/verbing/the/distance/forming》1978 紙、鉛筆、インク Arakawa Shusaku, *Subject/and/subjects/verbing/the/distance/forming*, 1978, paper, pencil, ink © 2020 Estate of Madeline Gins, reproduced with permission of the Estate of Madeline Gins	55.3× 110.3 cm

頁 Pages	作品 Works	寸法 Dimensions
076 右 Right	ブルーノ・ムナーリ《ジョコABC》(アルファベット・パズル)1960 樹脂 Bruno Munari, *Gioco ABC*, 1960, resin © Bruno Munari. All rights reserved to Maurizio Corraini s.r.l.	16.0× 16.0× 1.4 cm
077 左 Left	鈴木亘《Man Ray's Lip & Carve-Line》1974 樹脂 Suzuki Wataru, *Man Ray's Lip & Carve-Line*, 1974, resin	11.0×52.8×2.9cm 7.0×51.5×0.9cm
077 右 Right	荒川修作、マドリン・ギンズ《漂流物 標本函》の写真 1974頃 アクリル・ケース、写真(30枚) Arakawa Shusaku / Madeline Gins, Photographs of Specimen Boxes Containing Drifted Objects, ca. 1974, acrylic case, photographs (30 sheets) © 2020 Estate of Madeline Gins, reproduced with permission of the Estate of Madeline Gins	13.8× 16.1× 5.0 cm
078 左 Left	「JAPAN MONOPOLY CORPORATION」のメダル原形 石膏 Original Medal of "JAPAN MONOPOLY CORPORATION," plaster	6.6× 0.5 cm
078 中央 Middle	ジョアン・ミロからの贈り物 ミロのカラバサ 1976贈呈 植物 Joan Miró, Miró's Calabaza, gifted 1976, plant	19.0× φ23.0cm
078 右 Right	靉嘔《フィンガーボックス》1965頃 紙、スポンジ Ay-O, *Finger Box*, ca. 1965, paper, sponge	8.3× 9.2× 8.3 cm
079 左 Left	穴の空いた円錐 陶 Cone with Hole, ceramic	19.5× 8.7× 8.7 cm
079 中央・右 Middle, Right	藤田昭子(浜の子造形)《舞》《猿》《羊》1978頃 テラコッタ Fujita Akiko, *Dance, Monkey, Sheep*, ca. 1978, terracotta	18.7×9.8×7.1cm 7.0×5.0×6.5cm 4.1×8.0×4.3cm

◆ もりむらやすまさ コレクション Morimura Yasumasa collection

060-079	森村泰昌による制作物 作家蔵 Works by Morimura Yasumasa, Collection of the artist	—

その5 りったいさくひんの てんじしつ おおきなうちゅうは ちいさなはこの なかにある Room 5: Three-dimensional works A universe in a box

081-083	マルセル・デュシャン《トランクの箱》(特装版)1946 革製のトランクに納められたデュシャンの主要作品の複製及びオリジナル作品 Marcel Duchamp, *La boîte en valise* (Special version), 1946 reproductions of Marcel Duchamp's representative works and his original work in leather case © Association Marcel Duchamp/ADAGP, Paris & JASPAR, Tokyo, 2020	41.2× 38.6× 9.6 cm
084-087	森村泰昌《Du 茶庵》2020 ミクストメディア 作家蔵 制作:田中之博、井野敬裕 撮影:福永一夫 Morimura Yasumasa, *A Japanese Tea House for Marcel Duchamp*, 2020 mixed media, Collection of the artist, Production: Tanaka Yukihiro, Ino Takahiro, Photo: Fukunaga Kazuo	76.0× 70.0× 90.0 cm
088-089	山口勝弘《ヴィトリーヌ No.1》1952 ガラス、油彩、板 Yamaguchi Katsuhiro, *Vitrine No.1*, 1952, glasses, oil paints and boards	17.8× 21.0× 7.5 cm
090-091	森村泰昌《ヴィトリーヌのためのミラー・ボックス》2020 ミクストメディア 作家蔵 制作:田中之博 撮影:田中健司 Morimura Yasumasa, *A Mirror Box for Vitrine*, 2020, mixed media, Collection of the artist, Production: Tanaka Yukihiro, Photo: Tanaka Kenji	42.0× 36.5× 40.0 cm

その6 モリムラびじゅつし はくぶつかん ほんきでまねると ほんものになる Room 6: The Morimura Museum of Art History Be serious about copying, and you get the real thing

096 表紙 Front cover	森村泰昌《ほんきであそぶとせかいはかわる(ミロ A)》2020 カラー写真 Morimura Yasumasa, *Want to change the world? Be seriously unserious (Miró A)*, 2020 color photograph	137.0× 100.0 cm
098	森村泰昌《自画像の美術史(子供のためのアンリ・ルソー)》2016 カラー写真 作家蔵 Morimura Yasumasa, *Self-Portraits through Art History (Henri Rousseau for Children)*, 2016, color photograph Collection of the artist	145.0× 111.0 cm

頁 Pages	作品 Works	寸法 Dimensions
099	アンリ・ジュリアン・フェリックス・ルソー《私自身、肖像＝風景》1890　キャンバスに油絵具　プラハ国立美術館蔵 Henri Julien Félix Rousseau, *Moi-même, Portrait-Paysage*, 1890, oil on canvas Collection of The National Gallery Prague	143.0× 110.0 cm
100	森村泰昌《フェルメール研究（振り向く鏡）》2008　キャンバスに写真加工　作家蔵 Morimura Yasumasa, *Vermeer Study: Looking Back Mirror*, 2008, color photograph on canvas Collection of the artist	44.5× 39.0 cm
101	ヨハネス・フェルメール《真珠の耳飾りの少女》1665頃　キャンバスに油絵具　マウリッツハイス美術館蔵 Johannes Vermeer, *Girl with a Pearl Earring*, ca.1665, oil on canvas, Collection of The Royal Picture Gallery Mauritshuis	44.5× 39.0 cm
102	森村泰昌《自画像の美術史（レオナルドの顔が語ること）》2016/2018　雁皮紙にピエゾグラフ　作家蔵 Morimura Yasumasa, *Self-Portraits through Art History (What Leonardo's Face Says)*, 2016/2018, piezograph on Japanese paper Collection of the artist	33.3× 21.6 cm
103	レオナルド・ダ・ヴィンチ《自画像》1490または1515–16　紙に赤チョーク　トリノ王立図書館蔵 Leonardo da Vinci, *Autoritratto*, 1490 or ca.1515–16, red chalk on paper, Collection of Royal Library of Turin	33.3× 21.3 cm
104	森村泰昌《自画像の美術史（カラヴァッジョ／マタイとは何者か）》2016　カラー写真　作家蔵 Morimura Yasumasa, *Self-Portraits through Art History (Caravaggio / Who Is Matthew?)*, 2016, color photograph Collection of the artist	145.0× 218.5 cm
105	ミケランジェロ・メリージ・ダ・カラヴァッジョ《聖マタイの召命》1600頃　キャンバスに油彩　サン・ルイジ・デイ・フランチェージ聖堂蔵 Michelangelo Merisi da Caravaggio, *La Vocazione di San Matteo*, ca.1600, oil on canvas, Collection of Church of St. Louis of the French	322.0× 340.0 cm
106 左 Left	森村泰昌《自画像の美術史（デューラーの手は、もうひとつの顔である）》2016/2018　カラー写真、透明メディウム　作家蔵 Morimura Yasumasa, *Self-Portraits through Art History (Dürer's Hand Is Another Face)*, 2016/2018, color photograph, clear medium, Collection of the artist	67.0× 49.0 cm
106 右 Right	アルブレヒト・デューラー《28歳の自画像（1500年の自画像）》1500　板に油絵具　アルテ・ピナコテーク蔵 Albrecht Dürer, *Self-Portrait at the age of Twenty-Eight*, 1500, oil on panel, Collection of Alte Pinakothek	67.1× 48.9 cm
107 左 Left	森村泰昌《自画像の美術史（赤いターバンのファン・エイク）》2016/2018　カラー写真、透明メディウム　作家蔵 Morimura Yasumasa, *Self-Portraits through Art History (Van Eyck in a Red Turban)* 2016/2018, color photograph, clear medium, Collection of the artist	33.0× 26.0 cm
107 右 Right	ヤン・ファン・エイク《ターバンの男の肖像》1433　板に油絵具　ロンドン・ナショナル・ギャラリー蔵 Jan Van Eyck, *Portrait of a Man (Self Portrait?)*, 1433, oil on oak, Collection of National Gallery, London	26.0× 19.0 cm
108	森村泰昌《自画像の美術史（ゴッホ／青）》2016　キャンバスにインクジェット・プリント　作家蔵 Morimura Yasumasa, *Self-Portraits through Art History (Van Gogh / Blue)*, 2016, inkjet print on canvas, Collection of the artist	65.0× 54.5 cm
109	フィンセント・ファン・ゴッホ《自画像（渦巻く青い背景の中の自画像）》1889　キャンバスに油絵具　オルセー美術館蔵 Vincent Van Gogh, *Self-Portrait*, 1889, oil on canvas, Collection of Musée d'Orsay	65.0× 54.2 cm
110	森村泰昌《自画像の美術史（証言台に立つルブラン）》2016　カラー写真　作家蔵 Morimura Yasumasa, *Self-Portraits through Art History (Le Brun on the Witness Stand)*, 2016, color photograph Collection of the artist	145.0× 111.0 cm
111	エリザベート＝ルイーズ・ヴィジェ＝ルブラン《麦藁帽子の自画像》1782　キャンバスに油絵具　ロンドン・ナショナル・ギャラリー蔵 Élisabeth Louise Vigée Le Brun, *Self Portrait in a Straw Hat*, 1782, oil on canvas, Collection of National Gallery, London	97.8× 70.5 cm
112	森村泰昌《フェルメール研究（わが町に何を注ぐか）》2019　キャンバスにインクジェットプリント　作家蔵 Morimura Yasumasa, *Vermeer Study:What to Pour into My Town*, 2019, ink-jet print on canvas Collection of the artist	45.5× 41.0 cm
113	森村泰昌《モリメール写真館》2019　カラー写真　個人蔵　共同制作：和田大象、吉村睦人、大貫正恵、吉田恵子 Morimura Yasumasa, *Morimeer Photo Studio*, 2019, color photograph, Private collection, In cooperation with Wada Taizoo, Yoshimura Mutsuhito, Onuki Masae and Yoshida Keiko	45.5× 41.0 cm each
114	森村泰昌《もうひとつのマリリン》2015　カラー出力パネル　作家蔵　デジタル加工：井野敬裕 Morimura Yasumasa, *Another Marilyn*, 2015, Digital color printing on styrene board Collection of the artist, Digitalized: Ino Takahiro	90.0× 90.0 cm each
115	アンディ・ウォーホル《マリリン》1967　紙・シルクスクリーン Andy Warhol, *Marilyn*, 1967, silkscreen on paper © The Andy Warhol Foundation for the Visual Arts, Inc.	92.0× 92.0 cm each
117 裏表紙 Back cover	森村泰昌《ほんきであそぶとせかいはかわる（ミロ B）》2020　カラー写真 Morimura Yasumasa, *Want to change the world? Be seriously unserious (Miró B)*, 2020, color photograph	137.0× 100.0 cm

本書は富山県美術館で開催された企画展「森村泰昌のあそぶ美術史 ほんきであそぶと せかいはかわる」
（2020年3月7日〜5月10日）にあわせて刊行されました（掲載作品と展示作品は一部異なります）。

協　　　力　　富山県美術館
編 集 協 力　　渡辺希利子、湯佐明子（富山県美術館）
デ ザ イ ン　　三木健、犬山蓉子（三木健デザイン事務所）
翻　　　訳　　トム・ケイン

本書に関する森村泰昌作品制作チーム

福永一夫、田中之博、井野 敬裕、松本和史、邨田雄生実
吉田恵子、大村邦男、田中健司、森村利弥

This book was published for the exhibition *Morimura Yasumasa: Want to change the world? Be seriously unserious*,
presented at Toyama Prefectural Museum of Art and Design from March 7 to May 10 2020.
The works listed may differ slightly from the works exhibited.

Cooperation　　　　　　Toyama Prefectural Museum of Art and Design
Editorial cooperation　 Watanabe Kiriko, Yusa Akiko (Toyama Prefectural Museum of Art and Design)
Designers　　　　　　　Miki Ken, Inuyama Yoko (Ken Miki & Associates)
Translator　　　　　　 Tom Kain

Creative team of artworks by Morimura Yasumasa

Fukunaga Kazuo, Tanaka Yukihiro, Ino Takahiro, Matsumoto Kazuhito, Murata Oumi
Yoshida Keiko, Omura Kunio, Tanaka Kenji, Morimura Toshimi

ほんきであそぶとせかいはかわる
2020年3月7日　第1刷発行

著　　　者　　森村泰昌
発 行 者　　ジン・ソン・モンテサーノ
発 行 所　　LIXIL出版
　　　　　　 104-0031 東京都中央区京橋3-6-18
　　　　　　 Tel: 03-5250-6571　Fax: 03-5250-6549
　　　　　　 www.livingculture.lixil/publish

印 刷・製 本　　株式会社山田写真製版所

本書に収録しました作品のなかで、一部著作権不明のものがあります。
お心当たりの方は、LIXIL出版までご連絡ください。

Want to change the world? Be seriously unserious
First published in Japan on March 7, 2020

Author　　　　　Morimura Yasumasa
Publisher　　　　LIXIL Publishing
　　　　　　　　 3-6-18 Kyobashi, Chuo-ku, Tokyo 104-0031 Japan
　　　　　　　　 www.livingculture.lixil/en/publish

Printing & Binding　　YAMADA PHOTO PROCESS CO., LTD

This book includes orphan works whose copyright holders are either unknown or cannot be found.
If you have any information on the copyright holders, please contact LIXIL Publishing.

ISBN 978-4-86480-046-4　C0070　Printed in Japan
© 2020, Yasumasa Morimura
All rights reserved. No part of this publication may be reproduced without written permission of the publisher.